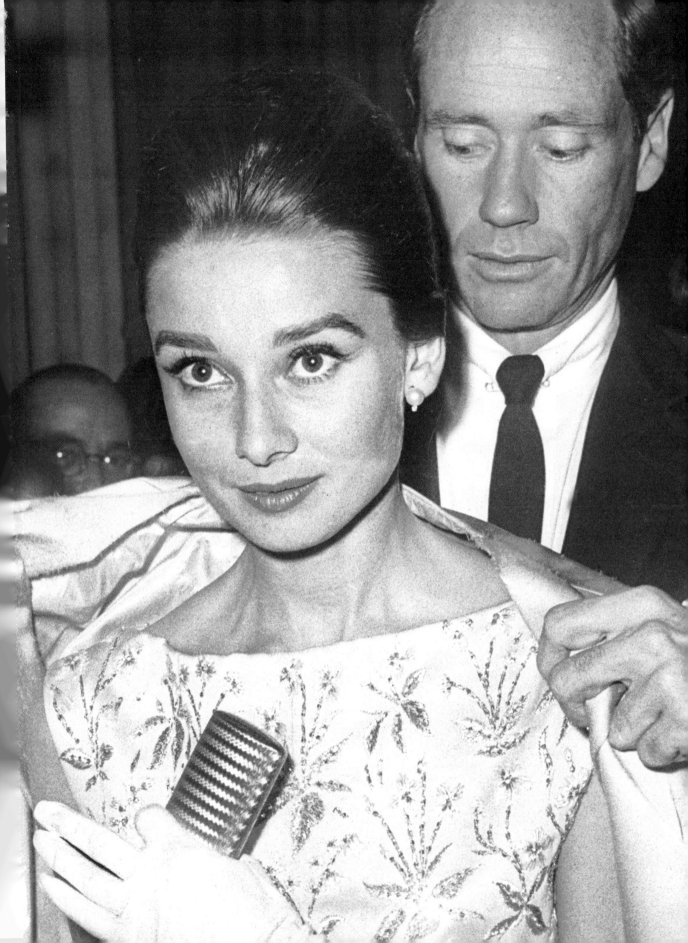

AUDREY IN ROME

AUDREY
IN ROME

Edited by
Ludovica Damiani and Luca Dotti

With text by
Sciascia Gambaccini

HARPER
DESIGN

An Imprint of HarperCollinsPublishers

Audrey in Rome

Original Italian edition 2011 published by Mondadori Electa S.p.A

First published in North America in 2013 by
Harper Design
An Imprint of HarperCollins*Publishers*
10 East 53rd Street
New York, NY 10022
Tel: (212) 207-7000
Fax: (212) 207-7654
harperdesign@harpercollins.com

Distributed in North America by
HarperCollins*Publishers*
10 East 53rd Street
New York, NY 10022
Fax: (212) 207-7654

ISBN 978-0-06-223882-5

Library of Congress Control Number: 2012941399

Printed in Italy by Mondadori Printing S.p.A.

Front cover photograph: Audrey on Rome's Via Bissolati, 1968.
Back cover photograph: page 192: Audrey on the set of *War and Peace*, 1955.

"Genius is 1 percent inspiration, 99 percent perspiration."
—Thomas A. Edison

This maxim holds true for my mother, part of whose life you will discover here, as well as for all those who in the creation of this project were not discouraged by the laws of physics. The authors wish to thank Emanuela Acito, Paolo Alberghetti, Stefania Baffa, Valter Bemer, Domitilla Bertusi, Jasmine Bertusi, Andrea Bini, Sava Bisazza Terracini, Caroline Bloxsom, Monica Brognoli, Doris Brynner, Caterina Cardinali, Daniele Chiocchio, Alberto Conforti, Monica Costa, Elisa Dal Canto, Sara De Michele, Giampiero Dotti, Mario d'Urso, Sean H. Ferrer, Ellen Fontana, Sciascia Gambaccini, Kitti Gentiloni, Caterina Giavotto, Valerio Gini, Maria Elisa Le Donne, Valentina Lindon, Giovanna Li Perni, Wayne Maser, Carmen Masi, Cristiano Migliorelli, Thomas Molteni, Stefano Peccatori, Anna Piccarreta, Virginia Ponciroli, Massimiliano Sagrati, Rossella Savio, Nicole Slovinsky, Raffaella Spadoni, Alessandra Spalletti, Luigi Spinola, Enrica Steffenini, Dario Tagliabue, Darren Thomas, Guido Torlonia, Olimpia Torlonia, Alessandra Umiliani, Elisabetta Umiliani, Violante Valdettaro, Vasco Valerio, Pierpaolo Verga, Nilzene Viana Anunciacao, and Luchino Visconti.

To Vincenzo, Marta, and Alice.
To my father, Andrea.

—*Luca Dotti*

CONTENTS

Introduction
Luca Dotti

A short time ago, while letting me off by my doorstep, a taxi driver said to me, "I know this place. Years ago I used to bring a beautiful woman here." That woman was my mother, but with the strange grace Romans can so unexpectedly display, he refrained from naming her. During the nearly twenty years in which my mother lived here, many people in Rome knew her the way that taxi driver did: as a woman who was fond of taking her children to school and of going on long walks with her dogs. Sometimes these private moments were captured when a photographer happened upon her as she stood on a side street near Campo de' Fiori with her husband, waiting for her mother-in-law to buzz them in for Sunday lunch.

Her life wasn't always like this—quite the opposite. My mother's fame began with her role in *Roman Holiday* (1953), made only a short time after World War II, when people were still recovering from the loss and deprivation it had caused. With that film, my mother became almost a second Colosseum: an icon of the city, of a different, free-and-easy Roman spirit that was symbolized by a girl who traveled the world on a Vespa. In 1955, she came to Rome again to film the colossal *War and Peace* at Cinecittà. When she stepped off the airplane at Ciampino airport, she was

welcomed as a foreign star (at the time mistaken for an American), but by then she was Roman by adoption.

These were the years of Rome as "Hollywood on the Tiber," a nickname that dated back to *Quo Vadis* (1950), when the city was transformed into a giant film set. The major film companies sent their stars to Rome, from Montgomery Clift to Orson Welles, from Shelley Winters to Ava Gardner. With investments from producers such as Carlo Ponti and Dino De Laurentiis, Italian cinema proved itself capable of giving lessons and collecting awards, even from Hollywood. Along with these producers came brilliant craftsmen who were inspired to create epic films; their efforts were made public by cunning press agents. The Romans experienced the real-life dream of seeing foreign celebrities descend from the silver screen to stroll the streets of their city, pursued by hordes of photographers eager to immortalize them.

In this environment, three years after King Vidor's *War and Peace*, my mother began filming *The Nun's Story* (1959) with director Fred Zinnemann. She confided to friends that she felt that this role was deeply hers—closer to the personal aspirations that would later lead her back to Africa as a UNICEF ambassador. She began to spend more time in Rome both on set and off, and her image evolved to include characteristics of the Roman spirit. This would not have been possible without the eye of costume designer Piero Tosi or the artistry of the De Rossis, the hairdresser Grazia and her husband, Alberto, a makeup artist and inventor of the "mascara look" and the "wing" eyebrows that forever framed my mother's face. She met them on set, but they remained close friends throughout her life.

In Rome, my mother inevitably became a protagonist of the snapshots taken by roaming freelance photographers, later dubbed "paparazzi" after Walter Santesso's character, Paparazzo, in Fellini's *La Dolce Vita*. Indeed, it was my

happening upon a photo by the great Rino Barillari that served as the inspiration for this series of shots that tells the story of Audrey in Rome.

Mamma was never caught off guard by photographers, at least not while doing anything worse than wearing a sleepy expression late at night in a club. Aided by her training in classical ballet, she naturally displayed impeccable composure on every occasion. Even so, she can't be given full credit for her dignified appearance. In those days, actors and photographers often developed friendships. My mother had her favorites, to whom she gave exclusive shots in exchange for impeccable images. Her favorite shots were those taken by Pierluigi Praturlon. Pierluigi was an omnipresent photographer of the "Hollywood on the Tiber" scene, and he was often requested to take photographs for William Wyler, King Vidor, Vittorio De Sica, and Federico Fellini. Pierluigi inspired the climactic scene in *La Dolce Vita*, having portrayed his friend Anita Ekberg illuminated by his car's headlights as she waded across the Trevi Fountain at the end of an evening of club-going. Actresses preferred even his off-set photographs, because while his photos celebrated the diva aspect of their personalities, Pierluigi was also able to capture something deeper.

Mamma trusted him. He captured her perfectly on the terrace of the Hotel Hassler when she opened the telegram announcing her New York Film Critics Circle best actress award for *The Nun's Story*. Pierluigi became a member of the family, one among the few invited to my parents' wedding in 1969. In the short movie of the event filmed by my uncle Luca, Pierluigi can be seen kissing my brother, Sean, on the forehead.

Over the years, I've met several people who claim to have introduced my parents. It is a fact that in 1961 my mother went to the premiere of *Breakfast at Tiffany's* in Rome with Olimpia Torlonia, my father's best friend, but years passed before my mother actually met him.

At the time of her marriage to my father and my birth in 1970, by her sole decision, my mother's public life as an actress and the days of paparazzi photographs came to an end. She slowly withdrew from the spotlight, and her priorities begin to change. And Rome made it possible.

Since the beginning of the 1960s, the busy star who joked at openings with Alberto Sordi and danced with Renato Rascel had been assembling a Roman circle of friends and making a home in the city. In Rome, Henry Fonda, who performed with my mother and Mel Ferrer in *War and Peace*, met and married an Italian, Afdera Franchetti. The couples saw one another frequently, and through Afdera and her sister Lorian, Mamma began to live the life of a true Roman. Perhaps in part because of its indolence, Rome always protected my mother, giving her time and space.

Although relatively brief, my mother's career was extremely intense, constructed using the discipline she had applied to her life since her childhood, a period painfully marked by World War II. At thirteen, she wanted to become a ballerina and began working hard toward achieving that goal. At sixteen, in Nazi-occupied Holland, she suffered from hunger. She survived by eating turnips and boiled tulip bulbs until the liberation, when she was saved by the newly formed United Nations.

Not even ten years passed before she became a star. But my mother had none of the tantrums we often associate with celebrity. Throughout her life she rose at dawn, a habit formed when she had to arrive on time to a set looking impeccable and knowing her lines by heart. I believe she still holds the record for magazine covers—she appeared on 650 of them. Without a doubt, this exposure meant a great deal of fame and a lot of glamour; but shooting that many magazine covers also meant she spent a total of nearly two years of her life doing only that. At a

certain point, she decided she wanted to do something else. She made that decision not once but twice: first to be a full-time mother, then to be a UNICEF ambassador. During both of those times in her life, public images of my mother grew increasingly rare and finally came to an end. My mother gave up film almost entirely. After her impromptu comeback in *Robin and Marian* (1976), directed by Richard Lester, she made few other films. She made her last appearance on screen in the role of an angel named Hap in the film *Always* (1989), directed by Steven Spielberg.

I've preserved the snapshots of those private years of the 1970s in my own photo albums, which are not unlike those kept by many other Italian families. In those photos Mamma takes me to the park or to swimming lessons; she meets with my teachers. She takes the dogs for walks. She learns her way around the small local grocery stores, Rome's famous *pizzicagnoli*. She cooks for herself and for friends, especially spaghetti al pomodoro, her favorite dish. By the time she left Rome in the mid-1980s, I was grown.

My mother's house in the Swiss countryside became the home base she returned to in order to rest and recharge before setting off once again for Africa, Latin America, or Asia to perform the humanitarian missions to which she dedicated the last period of her life. She sought to give other children the help she had received when she was a child; she sought to repay the good fortune she'd had. Those images are not included in *Audrey in Rome*, but the star Audrey Hepburn, the mother, and the UNICEF ambassador coexist happily in the person who appears in each photograph, whether public or private; she was always true to herself. A woman who loved to care for flowers, she cultivated her life with grace and dedication.

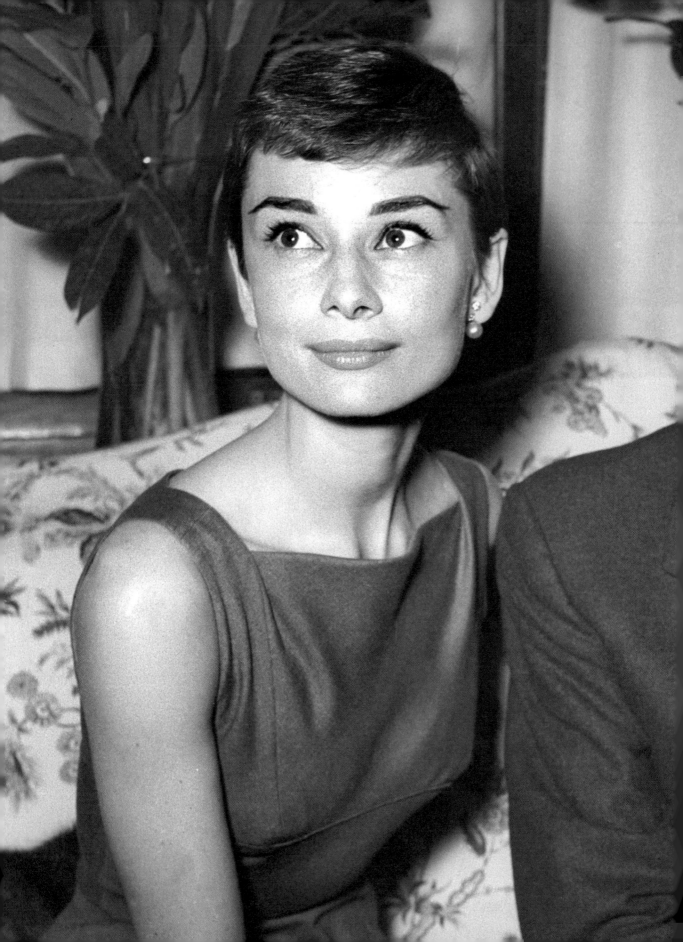

THE 1950s

After World War II, Italy fell in love with fashion, as if it were an elixir that promised a cure for all the years of destruction. The country began to embrace the new as well as to place a higher value on individual creativity, both of which shaped what became known as the made-in-Italy phenomenon.

Audrey Hepburn, with her frequent visits and long stays in Rome, brought Italy not only the glossy glamour of Hollywood but also a personal style that made her famous and irresistible.

During the early years of the 1950s, the great French couturiers reigned over an empire accessible to only a few women from the aristocracy and the film industry. Christian Dior revolutionized femininity and elegance after the hard times of the war years, presenting the New Look for women: a female perfectly silhouetted in her clothes, with an untouchable, regal allure.

Over the span of this decade Audrey represented the standard of an international, refined style, following, breaking, and enhancing new conventions of beauty with her combination of unrestrained glamour and disarming modesty.

Audrey was then at the apex of a career that kept her busy on two continents. Her impeccable style was reserved, but certainly not severe; her dresses reached below the knee to touch the calf, and her legendary slim figure perfectly fitted the new form, that of an adolescent and gamine sensuality, an open-eyed flirtation that drove even women crazy.

These were years in which women, traveling or just taking a stroll, always went out wearing gloves, swing coats, suits, and high heels. From 1954 on, Audrey was dressed by Hubert de Givenchy; their collaboration began with the film *Sabrina* and continued over the years with articles of clothing that are among the most emulated in the history of fashion. Audrey dressed in the full range of continental elegance as a woman who had French allure and American glamour without being one or the other. This mysterious fusion of sophistication and eccentricity made her captivating as the rebellious princess in *Roman Holiday*, the reluctant mannequin in *Funny Face*, and a nun in *The Nun's Story*.

Audrey's fashion stood out for its simplicity and softness, and Givenchy seemed to create outfits not to fit a given role but to complete the woman she represented in both her life and her work. "When I wear something from you, I feel secure, I feel protected," Audrey told him. Audrey's look, which was disciplined yet often unpredictable, made her attractive precisely because she was so delicate physically. Her style never once ran counter to that almost childlike enthusiasm, that joie de vivre that ran through her veins, that respect she had for her position at the center of the world, where there was room for everyone.

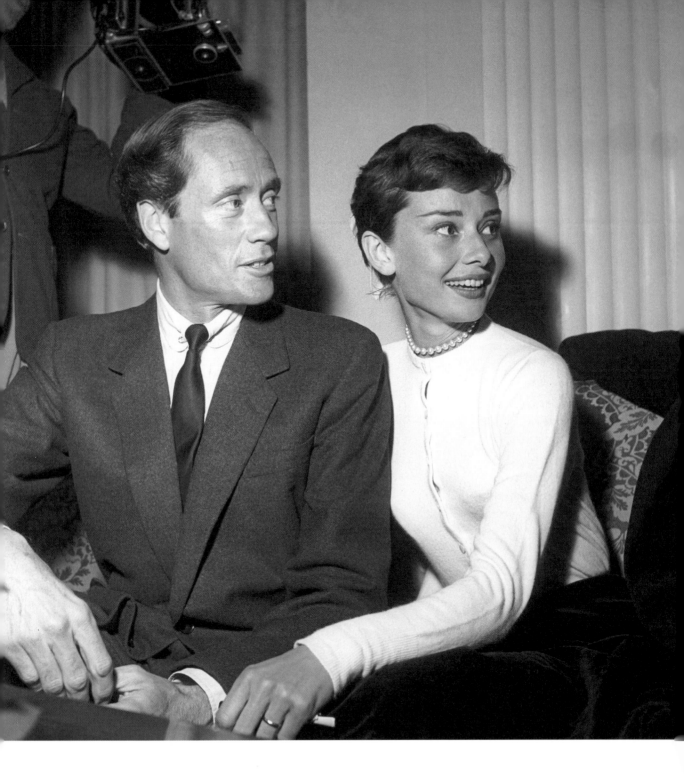

1955. Audrey with her first husband, Mel Ferrer, at a press conference for the film *War and Peace*. The two actors had married a year earlier, in September 1954.

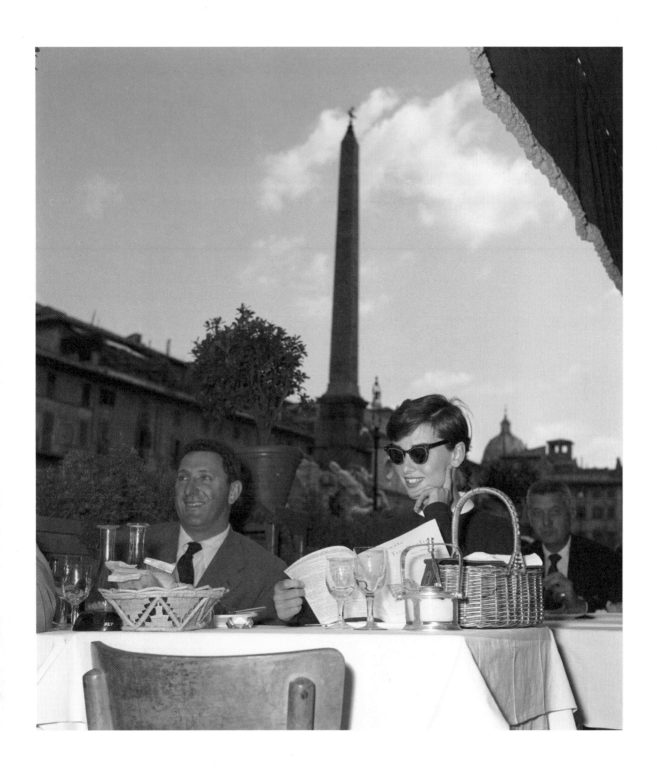

1955. Audrey having breakfast in Piazza Navona.

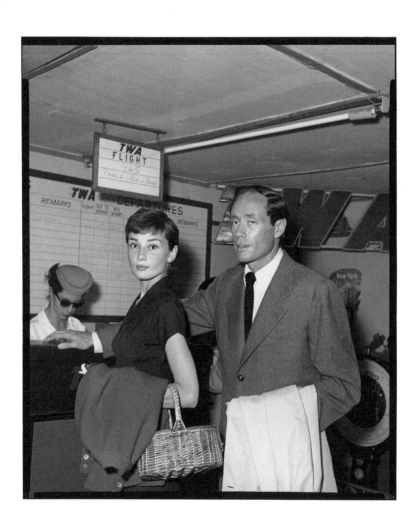

1955. With Mel Ferrer, departing from Rome's Fiumicino airport.

B

BASKET PURSE

Hardly convenient but chic without a doubt, the basket as a purse was an eccentric emblem of Audrey Hepburn.

Whether she carried the bag while traveling or dining out in a restaurant, wore it with a fur in the winter or with a summer suit, this accessory remained a constant in the actress's wardrobe, and was imitated by the major fashion houses of the world.

Over the years Audrey collected baskets of various types, from one custom-made by her friend Hubert de Givenchy to another handmade by children whom she met in Africa during one of her many UNICEF trips. While styles changed, some things remained the same for Audrey: even during her last years, she strolled in the garden of her house *La Paisible* ("The Peaceful") in Switzerland with her basket in hand, collecting the roses she loved so much.

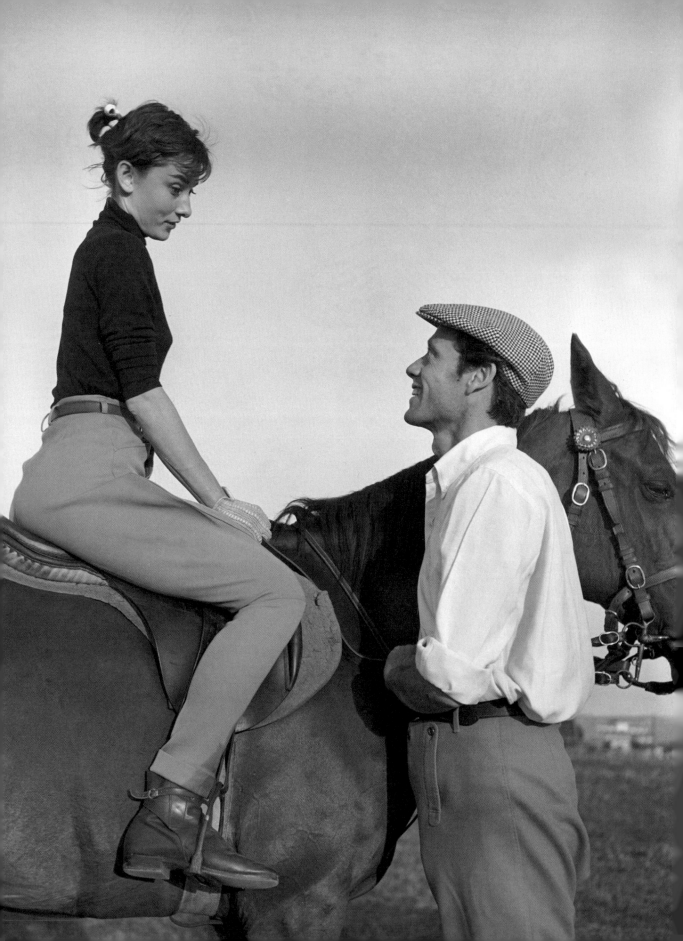

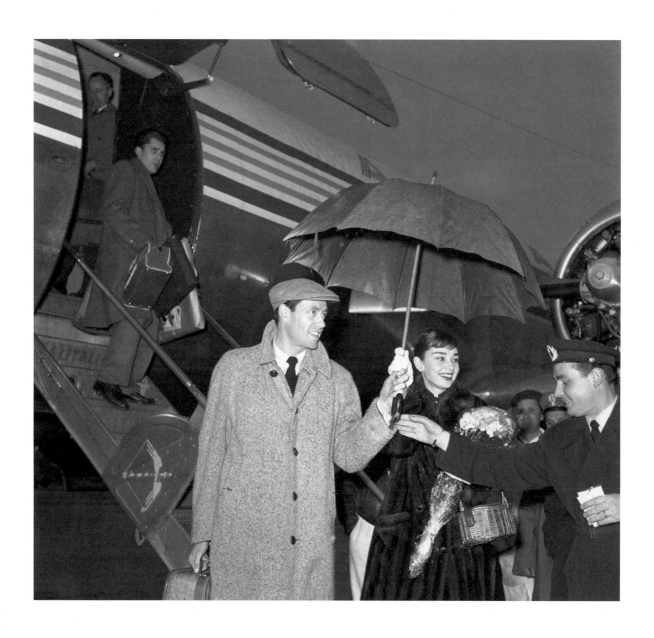

Opposite:
1955. Andrey on horseback
with Mel Ferrer during the
filming of *War and Peace*.

1956. Arriving at Rome's
Ciampino airport with Mel Ferrer.

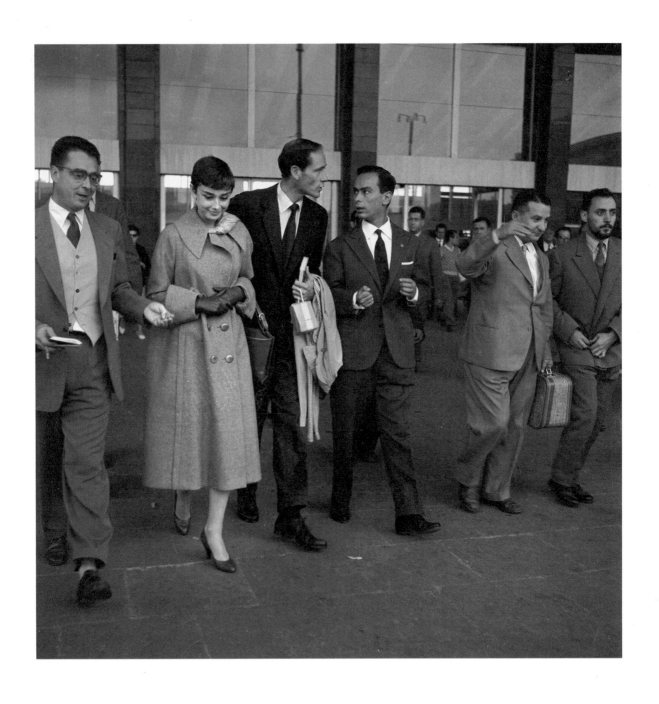

1956. Audrey and Mel Ferrer arriving at Rome's Termini train station.

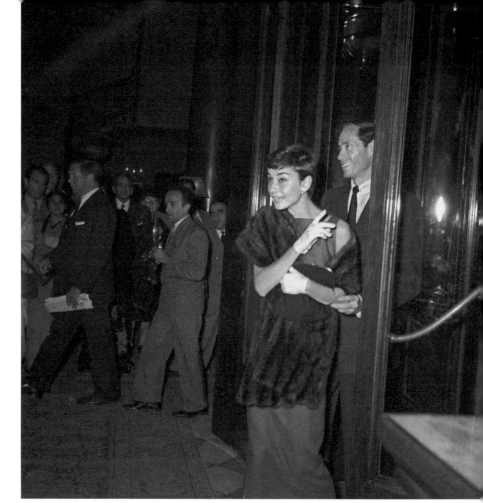

The "Sabrina" neckline of Audrey's long sheath dress was designed by her friend Hubert de Givenchy to hide her prominent collarbone. In an era of buxom leading ladies, Audrey was the icon of a different femininity, one who went against the aesthetic dictates of the time.

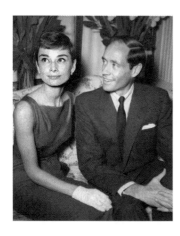

1956. Audrey with Mel Ferrer.

1957. Audrey and Mel Ferrer setting off from
Ciampino airport on one of the many promotional film
campaigns that were required of actors at the time.
These campaigns required travel in the United States
and throughout Europe, and the physical demands
of those trips were greater than they are today:
plane accommodations were not as comfortable
as they are now and making flight connections was
not as convenient, often requiring long stopovers.
As a result, an actor on a European tour might visit
London, Rome, and Paris within the span of just
twenty-four hours to make the best use of time.

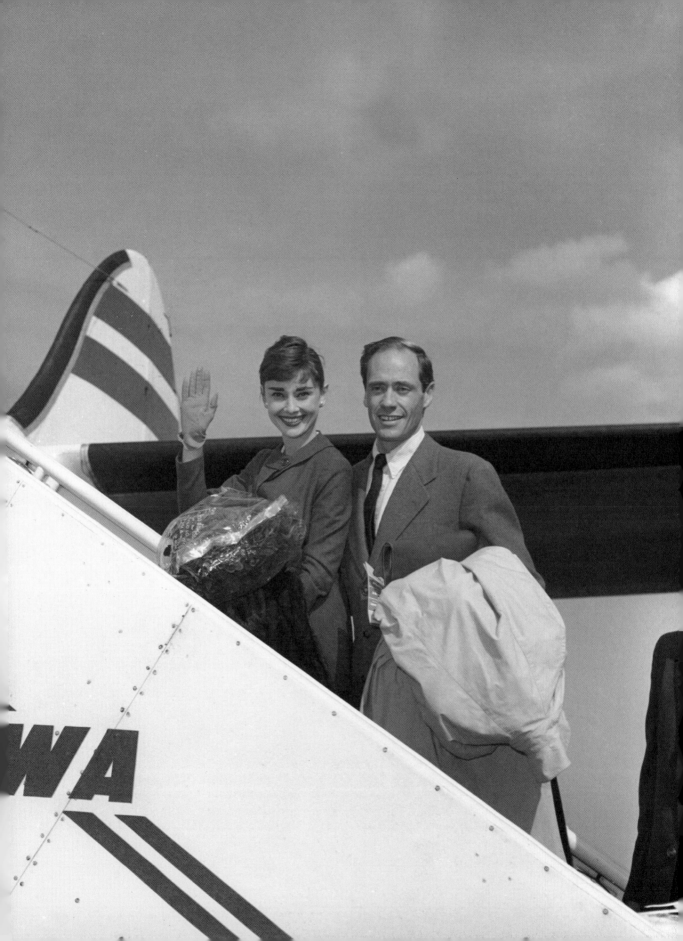

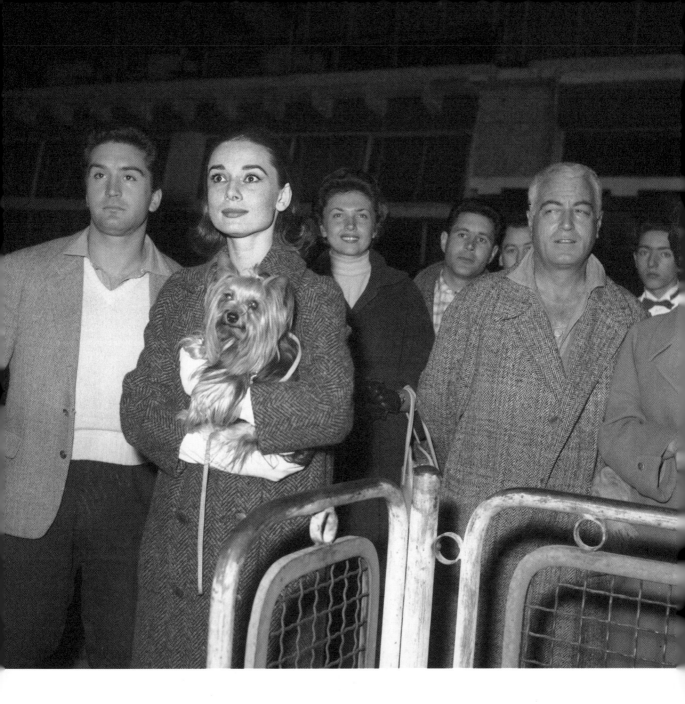

1958. *This page and opposite*:
Audrey meeting her husband Mel
Ferrer at Ciampino airport. She's
holding Mr. Famous, her Yorkshire
terrier. *Above*: Audrey's hairdresser
Grazia De Rossi stands directly
behind her. Grazia's husband,
makeup artist Alberto De Rossi, is
the white-haired man to the right
of the frame. The De Rossis worked
closely with Audrey throughout her
entire career.

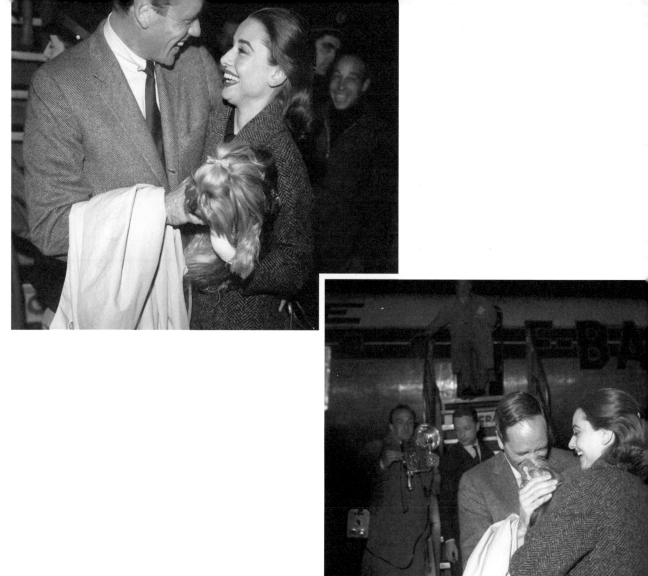

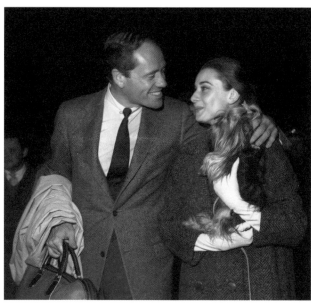

1958. Audrey with her husband Mel Ferrer. The couple
made two films together, *War and Peace* (1956),
directed by King Vidor, and *Green Mansions* (1959),
directed by Ferrer himself.

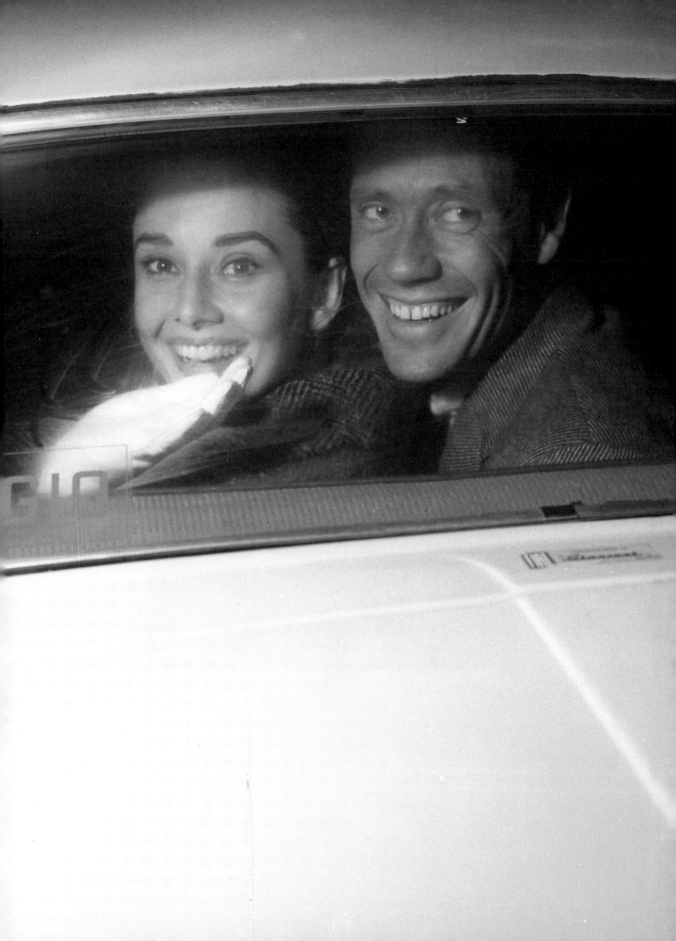

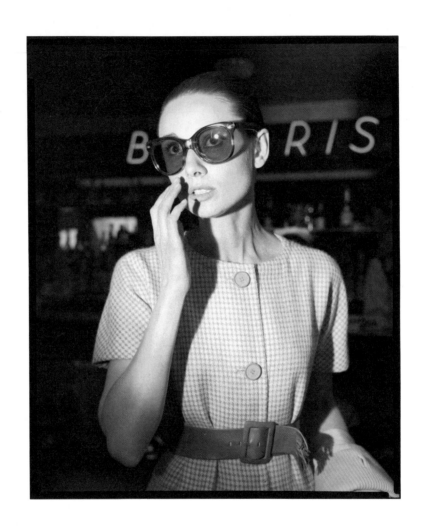

EYEGLASSES, AUDREY-STYLE

Audrey confided to her friend Doris Brynner that she had truly small eyes and that her legendary wide-eyed look was only a trick of makeup carried out expressly for the camera.

Without a doubt, this unfounded conviction, whether an expression of modesty or incurable timidity, was rendered moot after the film *Breakfast at Tiffany's*: oversize dark glasses became a signature component of Audrey's look, the look with which she invented new rules of seduction based on mystery and intellect as well as style and humor. If the "trick," as she called it, was in the makeup, then the eyeglasses contributed to the illusion, raising her eyebrows and rounding the slightly square outlines of her face—all accomplished with her usual absolute elegance.

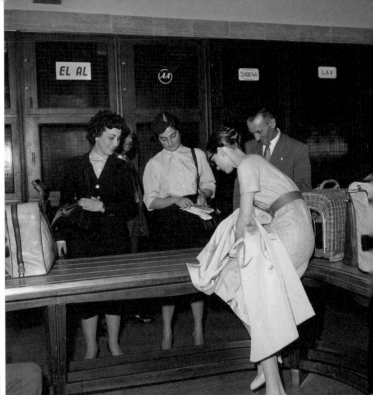

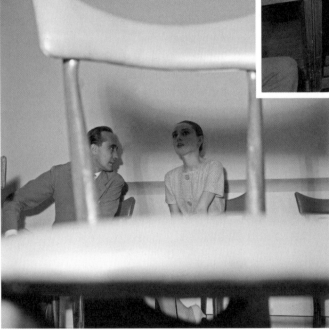

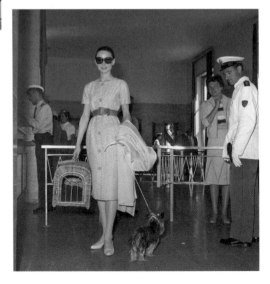

These pages and page 32:
June 16, 1958. Audrey leaving
from Ciampino airport
after a press conference.
In the photograph above,
she is chatting with Italian
journalist Lello Bersani.

Audrey was impeccable—
never wrinkled—even
on the road, and the
traveling basket for her
Yorkie (*opposite, below*)
matched her traveling
look. The golden thread
of elegance followed
Audrey everywhere.

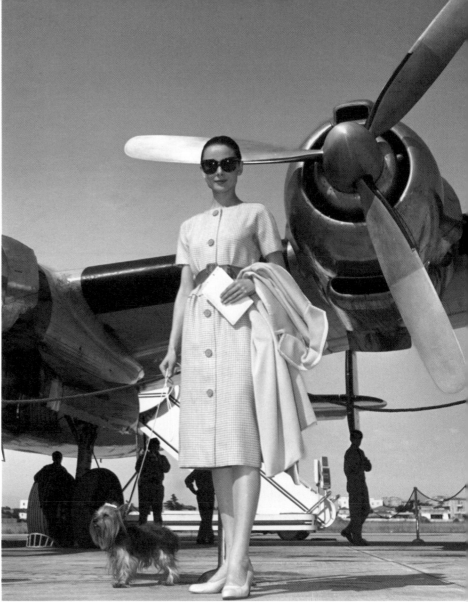

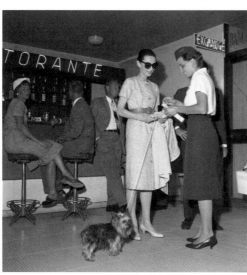

A true trendsetter, Audrey
had her favorite couturiers
transform the silk she
acquired during her travels
into splendid evening outfits.

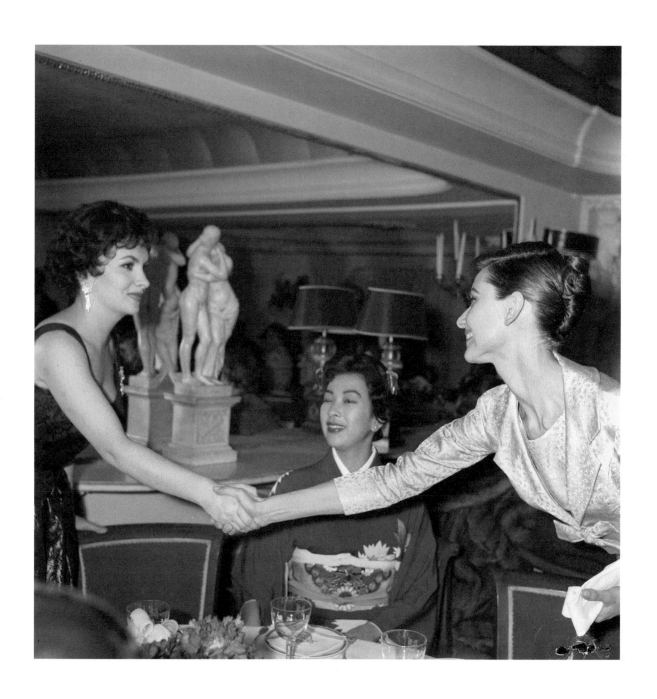

1958. Audrey at the premiere of the film *Sayonara* (1957), directed by Joshua Logan. In this picture she appears with Gina Lollobrigida and the film's female lead, the Japanese actress Miiko Taka.

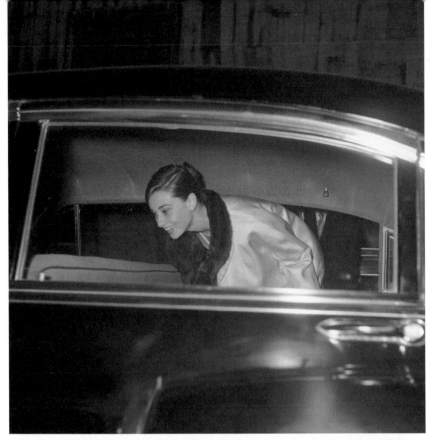

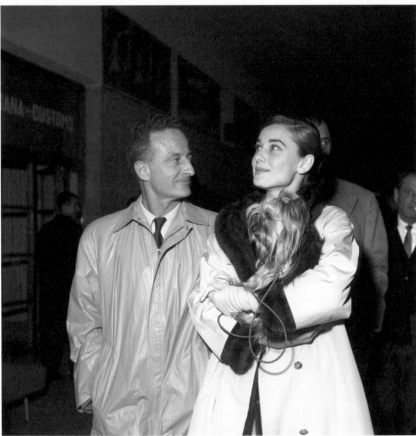

1958. Audrey at Ciampino airport. *At left* she is with director Fred Zinnemann. Together they made *The Nun's Story*.

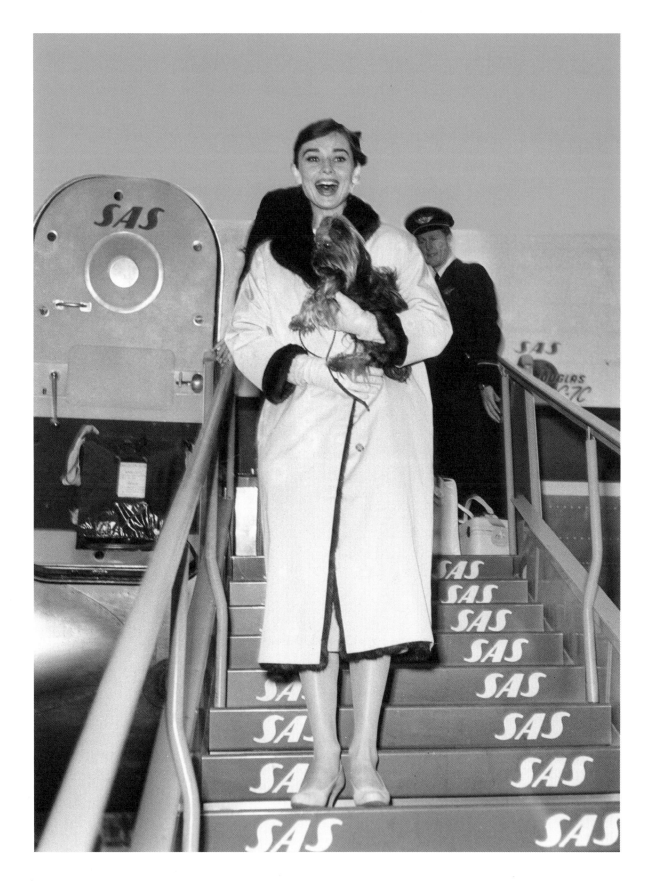

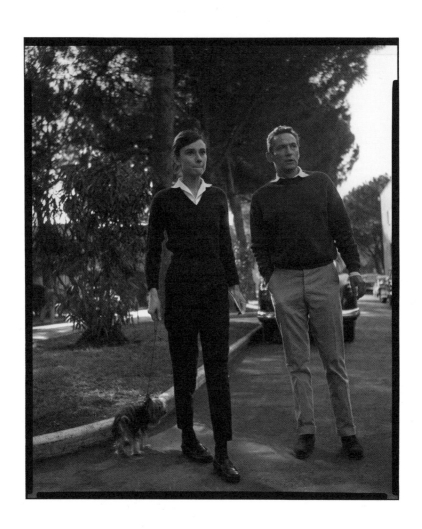

1958. Audrey in the gardens at Cinecittà with Australian actor Peter Finch, a costar in *The Nun's Story*.

LOAFERS FOR WOMEN

Aside from dozens of pairs of ballet flats, Audrey's shoe wardrobe contained numerous pairs of casual footwear, from driving loafers by Gucci to those designed by Salvatore Ferragamo. The flat shoe, a little masculine, was another one of Audrey's trademarks, a look that was halfway between American preppy and French gamine. In *Funny Face* she lets loose in a sort of interpretive dance in a bohemian café, wearing a black sweater, ankle-length pants, and penny loafers. This style was adopted by another Hepburn (Katharine), who used it to affirm the almost androgynous power of her character; on Audrey, though, it was a message of undisputed femininity.

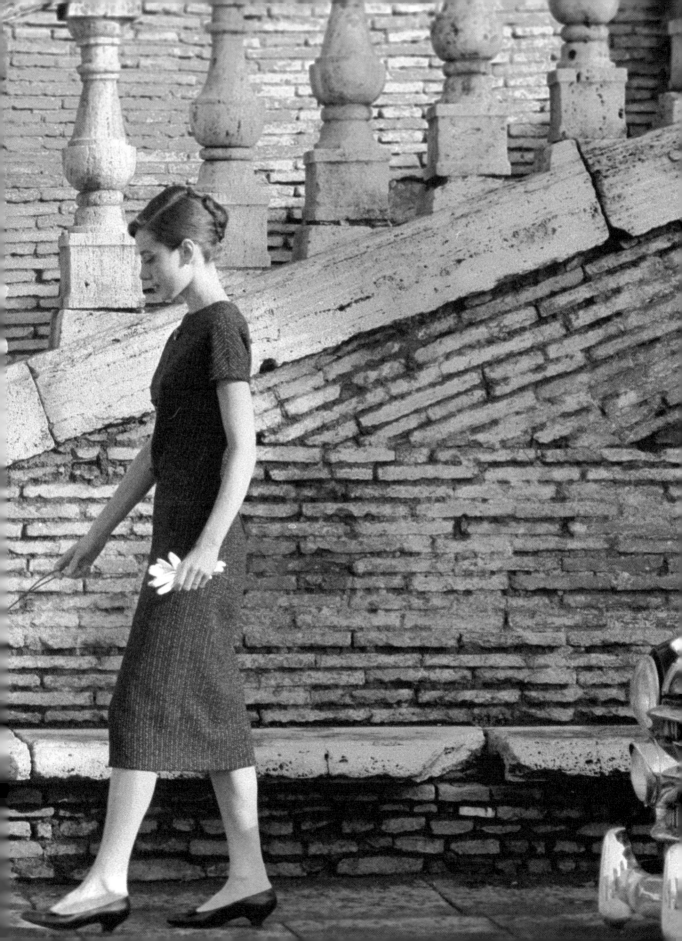

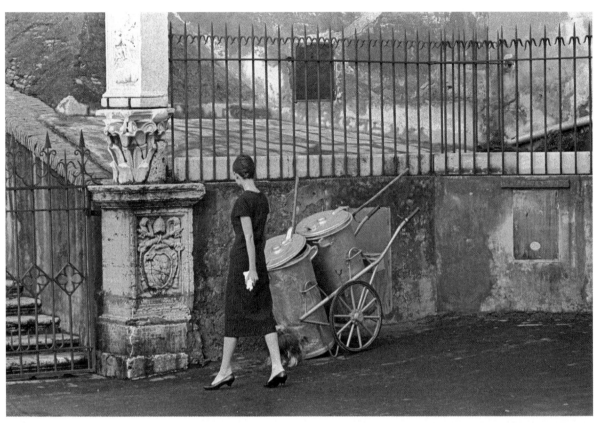

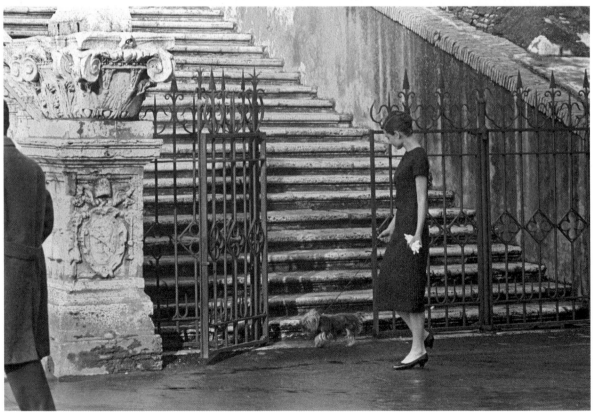

The essentials of elegance in the 1950s were iconic classics and thus very much Audrey Hepburn: a black dress just below the knee, a low heel, white suede gloves, and hair styled into a chignon.

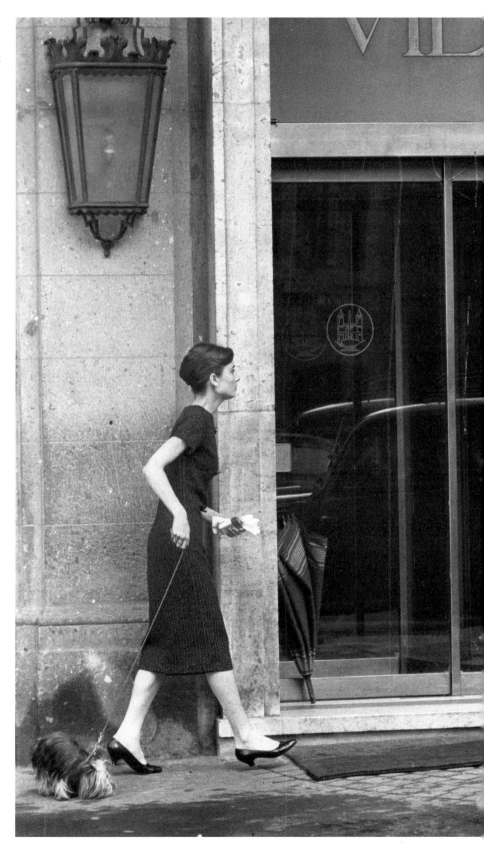

*This page and
the preceding pages:*
1958. Walking Mr. Famous
around Trinità dei Monti.

One of the rare images of
Audrey with her hair loose,
making visible the famous
highlights so characteristic
of her look in *Breakfast at
Tiffany's*. There is refined
eccentricity in the choice
of the satchel purse and
the somewhat masculine,
slightly flared tweed coat.

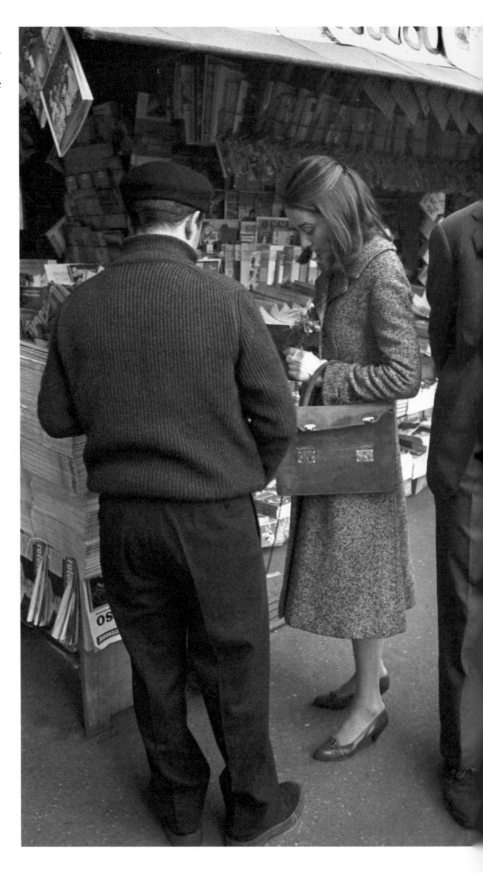

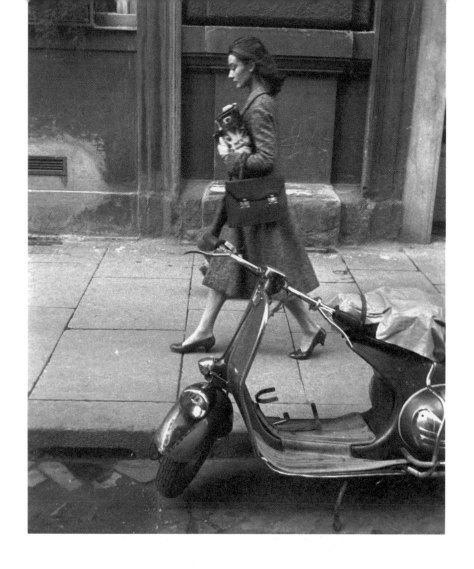

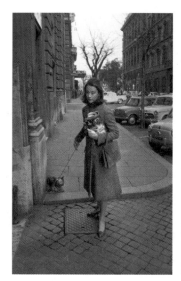

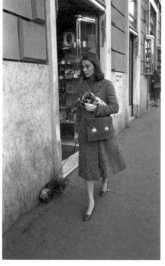

1959. Audrey on the streets of Rome.

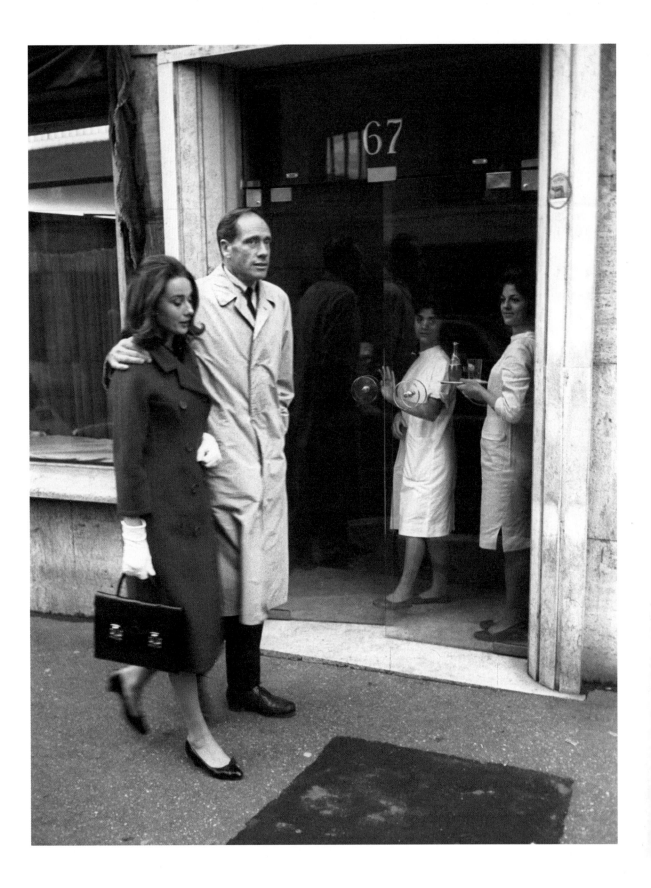

Opposite: 1959. Audrey with
Mel Ferrer on a street
in Rome's city center.

This page: 1959. Audrey and
Mel Ferrer departing from
Ciampino airport.

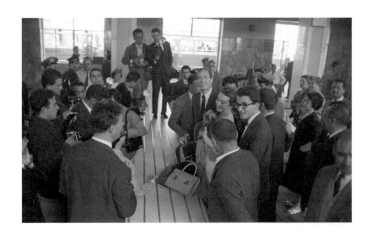

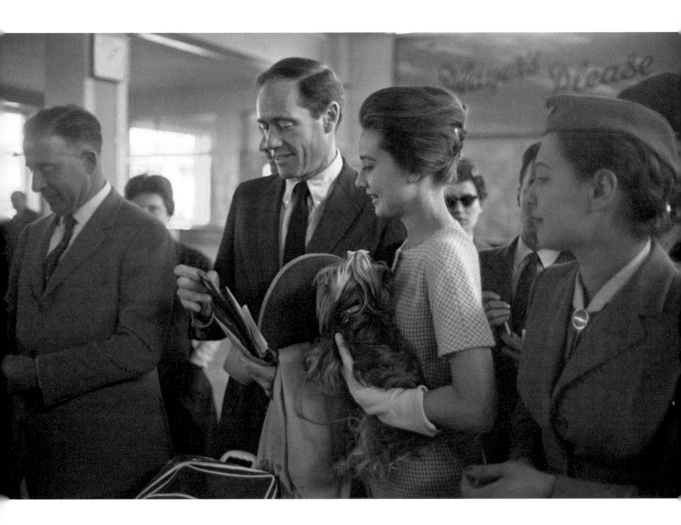

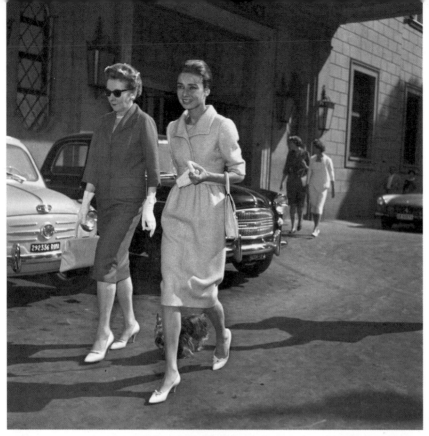

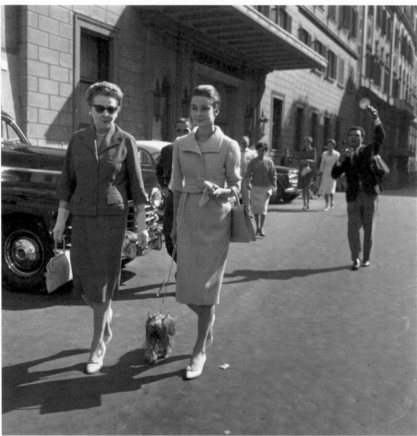

*This page and
the following pages:*
1959. Audrey at Trinità dei
Monti and on the Spanish Steps
with her mother, Baroness Ella
van Heemstra.

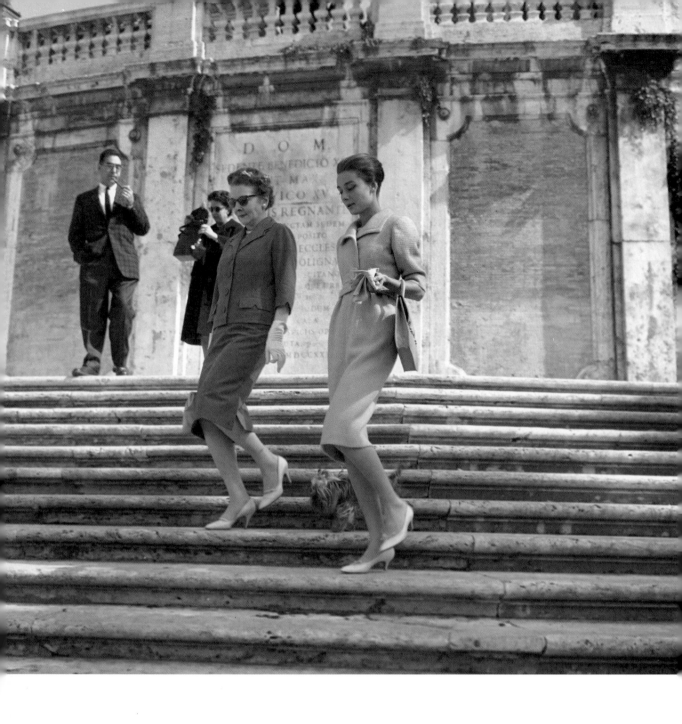

Harmony between mother and daughter: aside from their gait (they are taking almost identical steps), there is the choice of a sack suit for the mother and a slim, tight-waisted suit for the daughter. The three-quarter sleeves were de rigueur at the time.

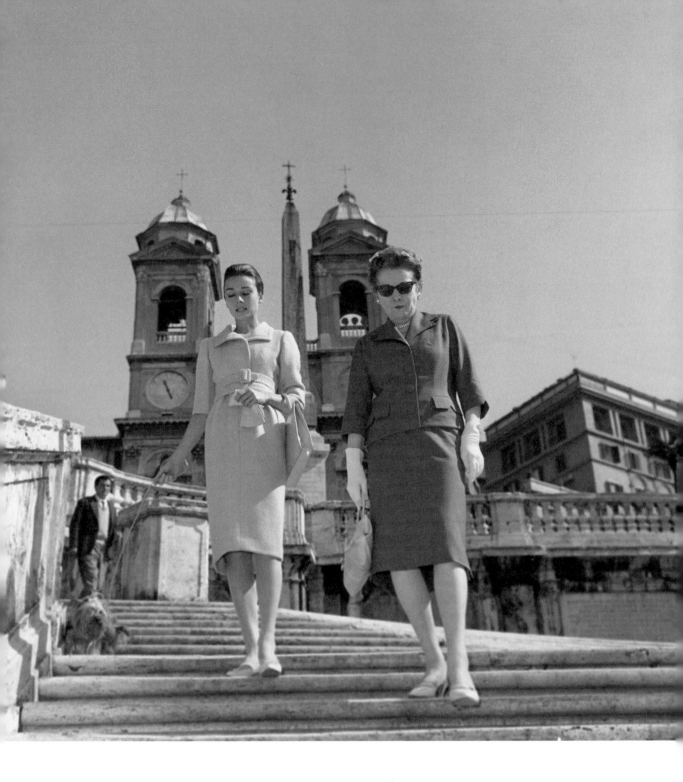

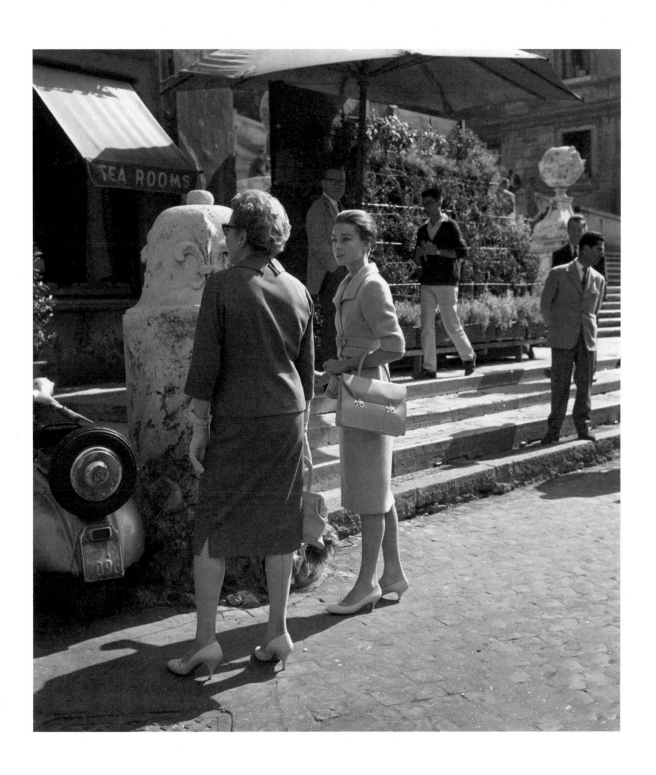

1959. Audrey with her mother, Baroness Ella van Heemstra, in Piazza di Spagna, in front of Babington's famous tea rooms.

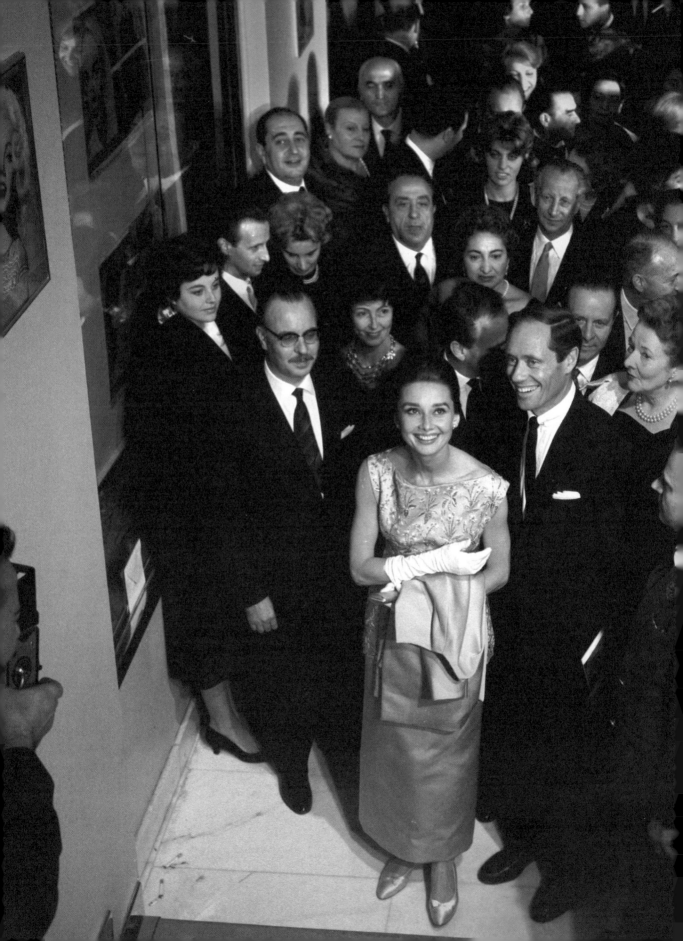

At the premiere of *The Nun's Story*, all eyes are on Audrey. The shiny silk Mikado dress and shoes made from the same fabric are completed by a collar-less evening jacket. She wears opera-length gloves and, notably, wears no flashy jewelry.

1959. Audrey with Mel Ferrer at the premiere of *The Nun's Story*, directed by Fred Zinnemann, at the Cinema Fiammetta on Via Carducci.

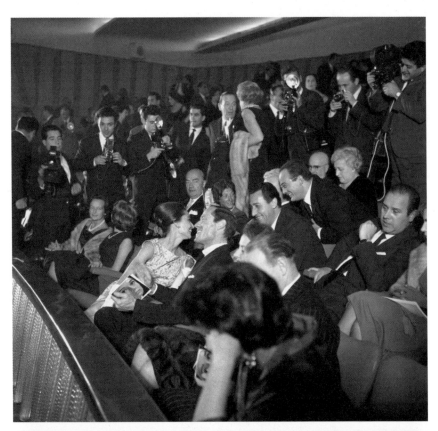

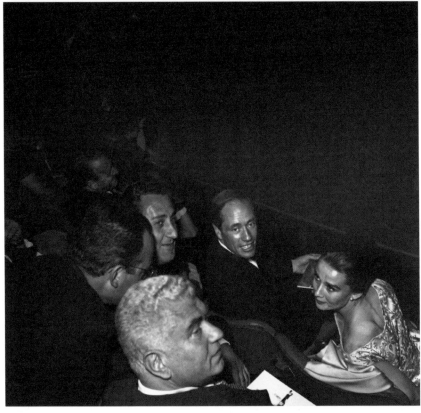

1959. Audrey and Mel Ferrer chatting with actor Alberto Sordi, producer Dino De Laurentiis, and actor Gino Cervi.

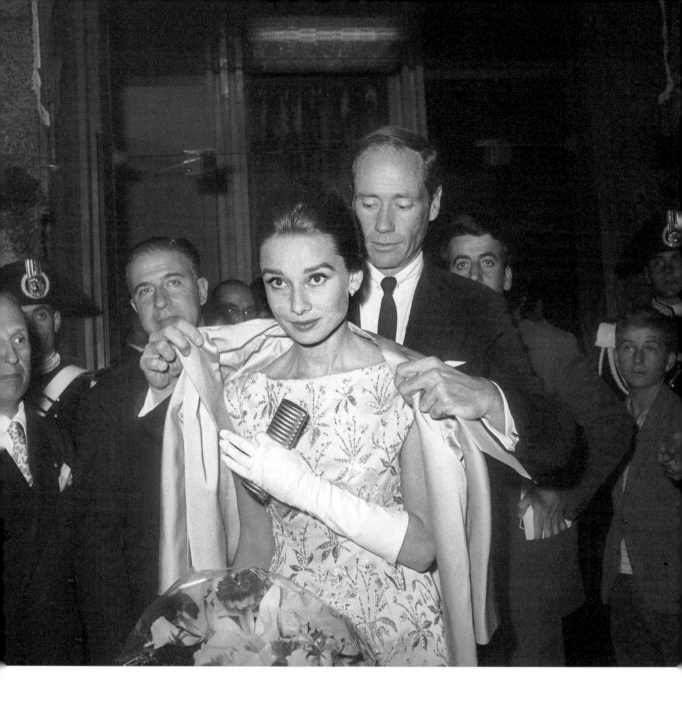

1959. Audrey and Mel Ferrer leaving after the showing of *The Nun's Story*.

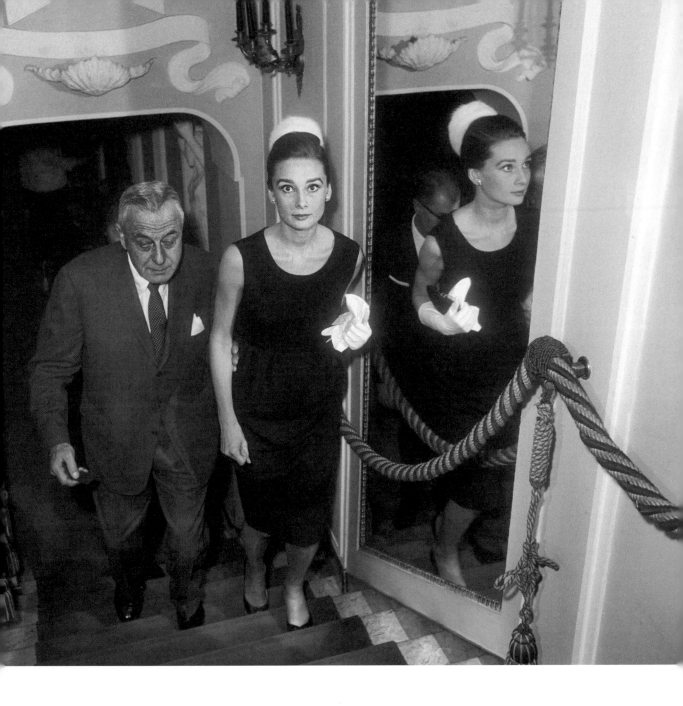

1959. Audrey on her way to a cocktail party.

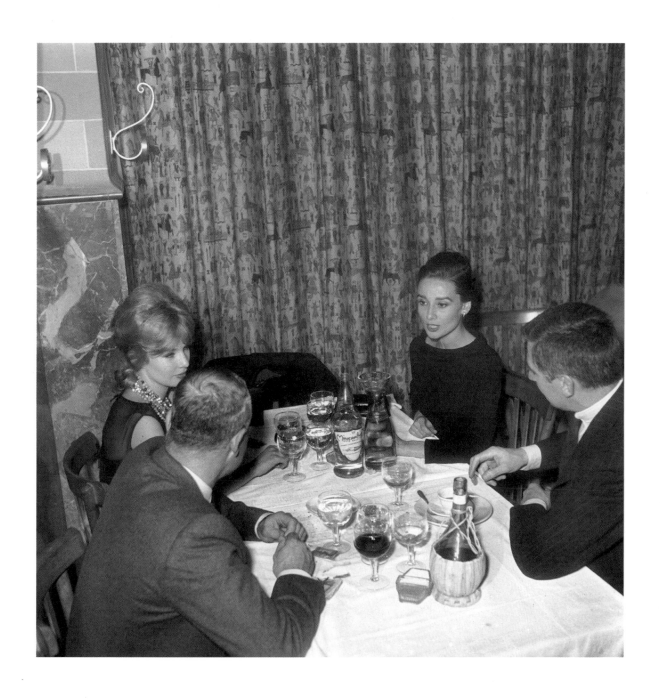

1959. Audrey seated opposite Danish actress Annette Stroyberg during a dinner at Corsetti's, in Trastevere.

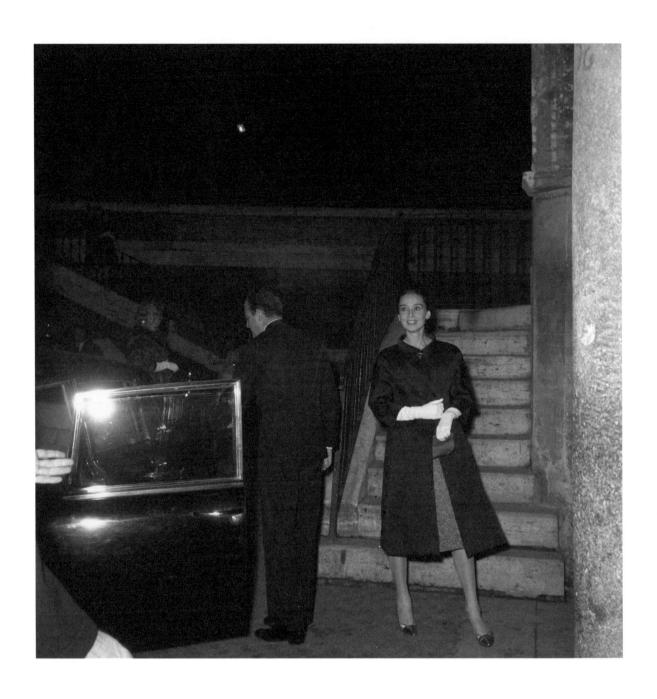

1959. Audrey at the entrance to
La Cabala, the famously exclusive
nightclub on Via dell'Orso, for
New Year's Eve.

Opposite:
1959. Audrey at Trinità dei Monti.
Behind her is Villa Medici, headquarters
of the French Academy in Rome.

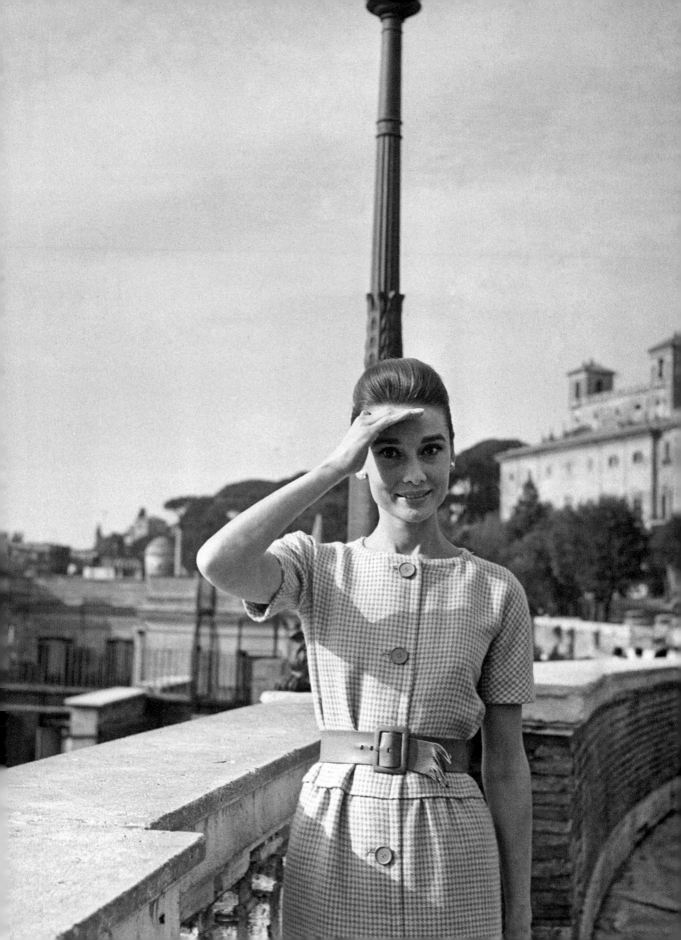

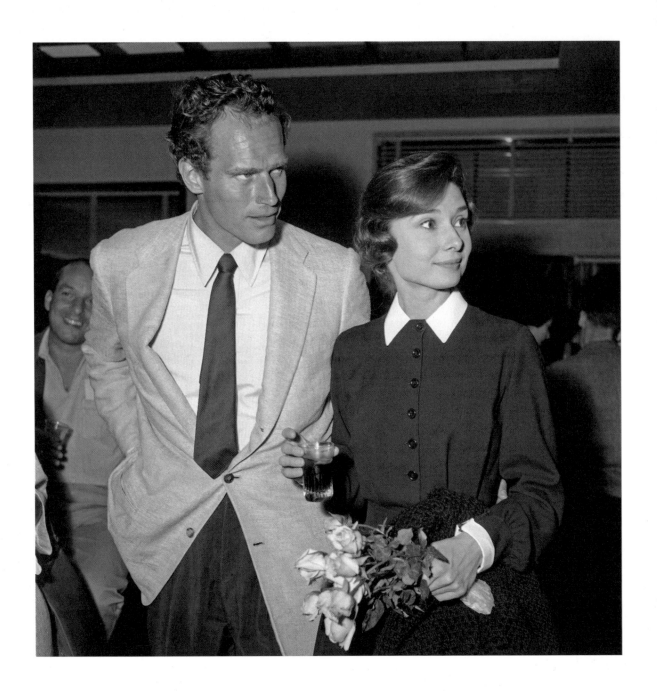

1959. At Cinecittà, while filming
The Nun's Story, Audrey met
Charlton Heston at a cocktail
party for the epic *Ben-Hur*,
directed by William Wyler. Wyler
directed Audrey three times, in
Roman Holiday, *The Children's
Hour*, and *How to Steal a Million*.

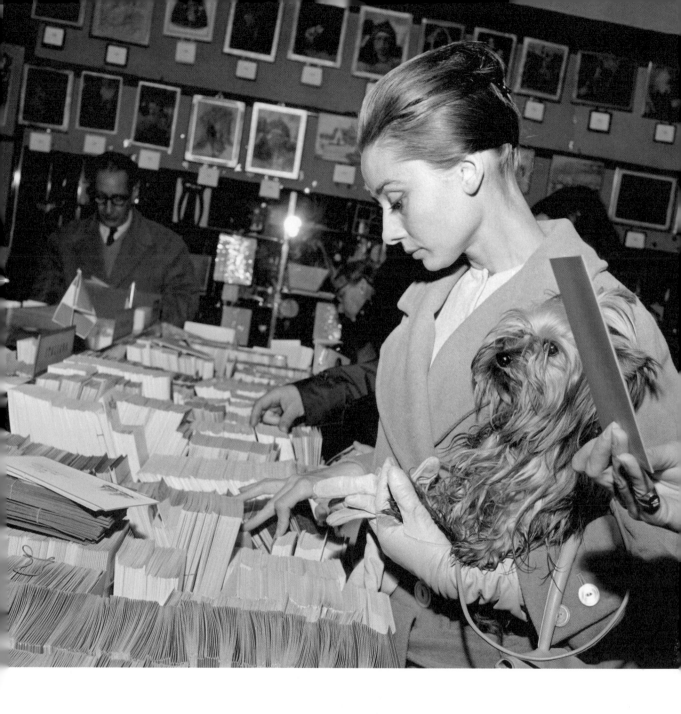

December 21, 1959. Audrey and
Mr. Famous browsing through
postcards.

At Work on the Set

Audrey performed in fewer than thirty films. Three were made in Rome—each of them a milestone in her career. *Roman Holiday*, directed by William Wyler, ranks among the most famous films in the history of cinema; it catapulted Audrey to international fame and made the Vespa a symbol recognized throughout the world. In *War and Peace*, directed by King Vidor and still considered one of the greatest historical epics, Audrey acted with her husband Mel Ferrer in her first color film. *The Nun's Story*, directed by Fred Zinnemann, praised by critics and the public alike and filmed in large part on the sets of Cinecittà, offered Audrey her favorite role.

Above and opposite:
1952. Audrey and Gregory Peck during a pause in the filming of *Roman Holiday* (1953), directed by William Wyler; on the Spanish Steps (*above*) and at the Colosseum (*opposite*), with the Palatine Hill in the background.

At right:
1952. Audrey, filming an interior scene of *Roman Holiday*, standing in the splendid Galleria of Palazzo Colonna in Piazza Santi Apostoli.

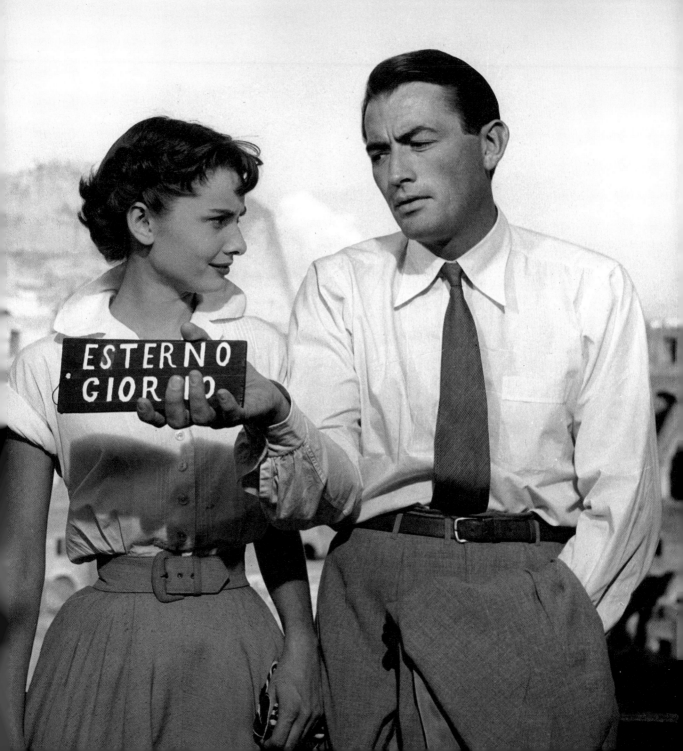

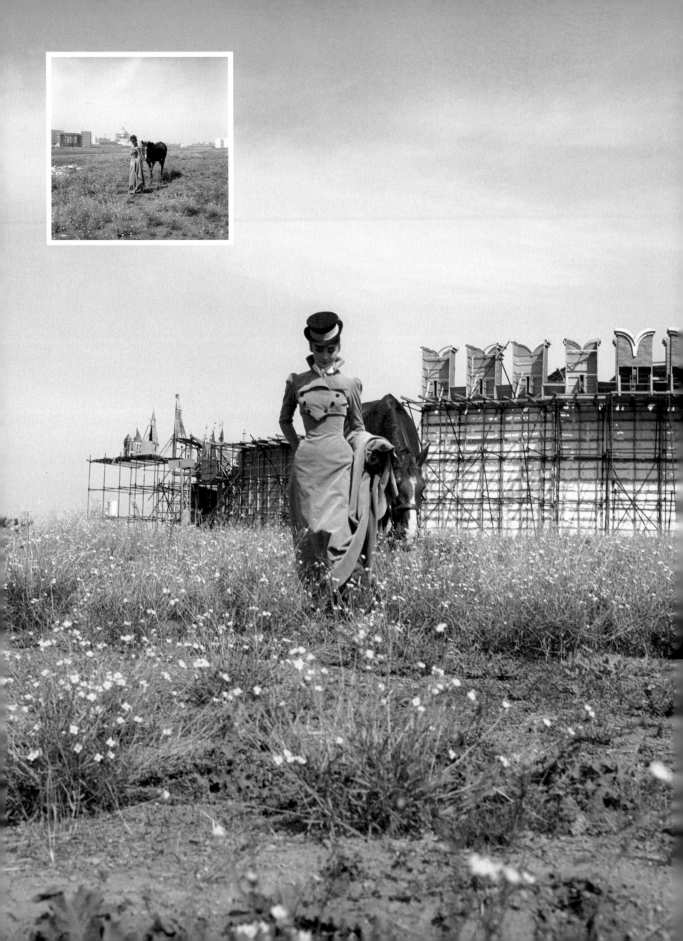

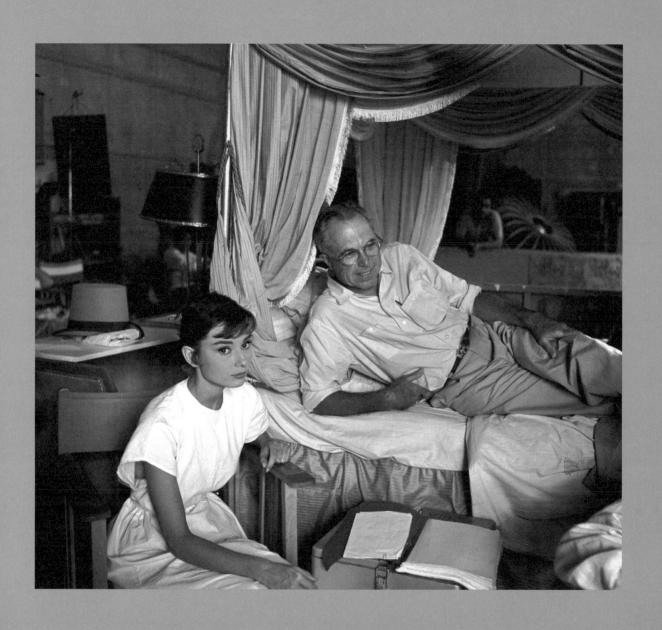

1955. Audrey at Cinecittà during the filming of *War and Peace* (*opposite*) and with director King Vidor (*above*).

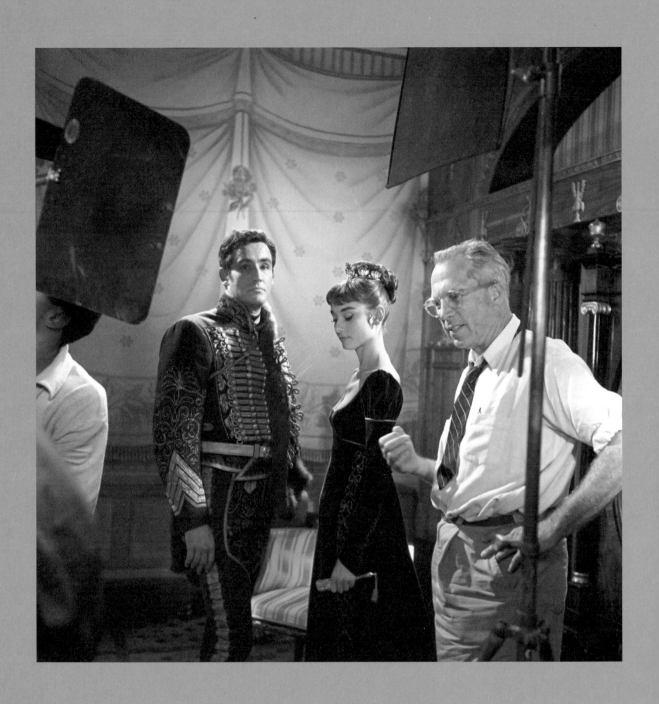

1955. Audrey with actor Vittorio
Gassman (*left*) and King Vidor (*right*).

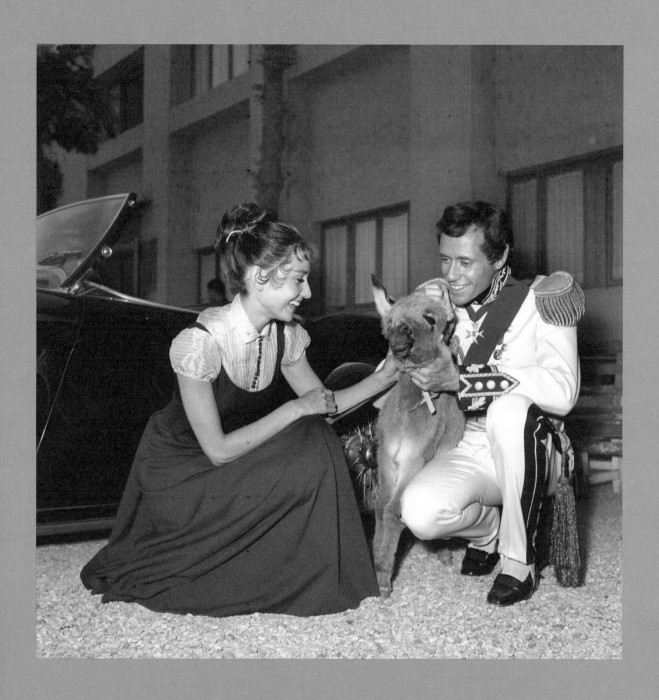

1955. Audrey with Mel Ferrer and
a baby donkey during a break in
the shooting of *War and Peace*.
Audrey always had a great passion
for animals. She cared for the fawn
that performed with her in *Green
Mansions* (1959), took it home with
her, and nicknamed it Ip.

1955. On the set of *War and Peace* at Cinecittà. The epic film, produced by Carlo Ponti and Dino De Laurentiis, with music by Nino Rota, art direction by Mario Chiari, set decoration by Piero Gherardi, and costumes by Maria De Matteis, was filmed entirely in Italy, in the Cinecittà studios and around Turin and Mantua. The film's winter setting required the manufacture of tons of artificial snow.

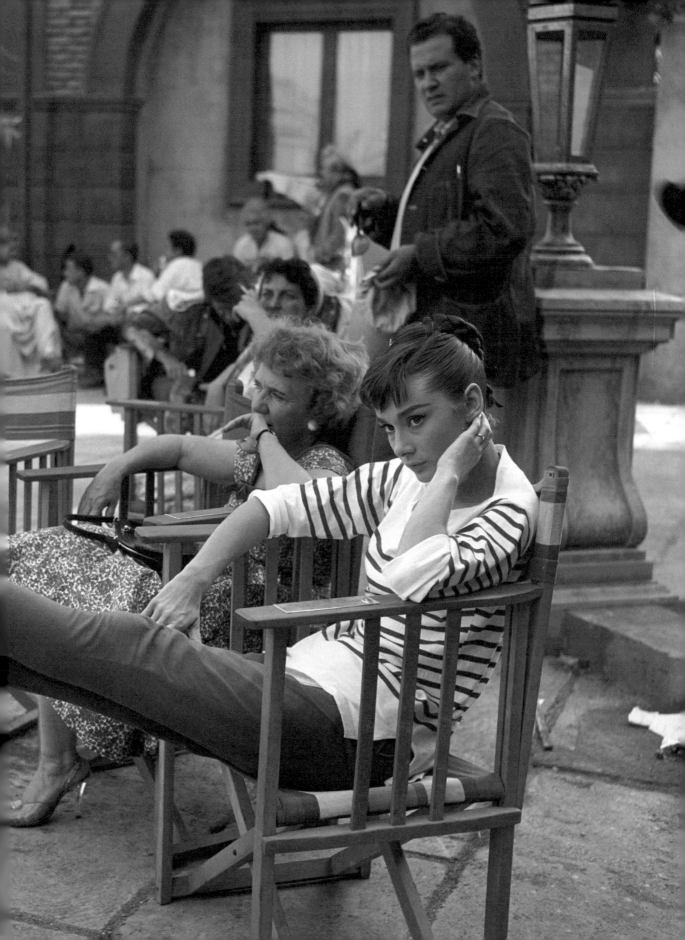

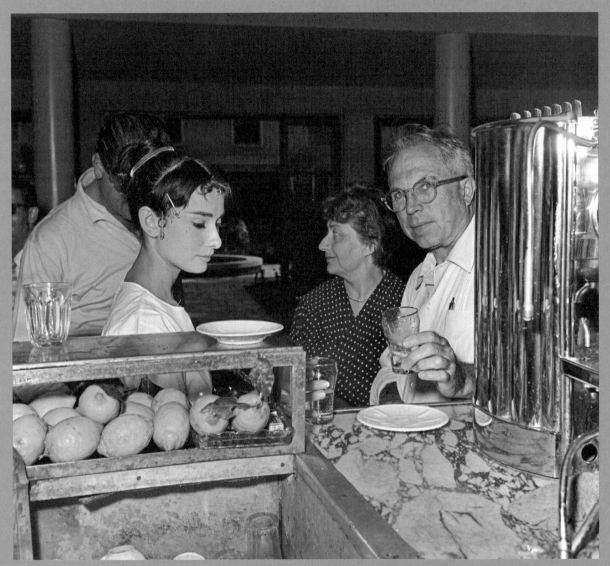

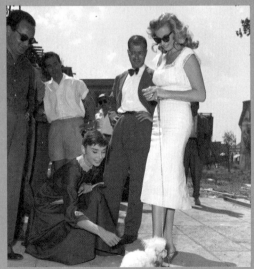

Above:
1955. Audrey with King Vidor in Cinecittà's legendary bar.

Left:
1955. Audrey during a break on the set, with Swedish actress Anita Ekberg (*right*) and producer Dino De Laurentiis (*left*).

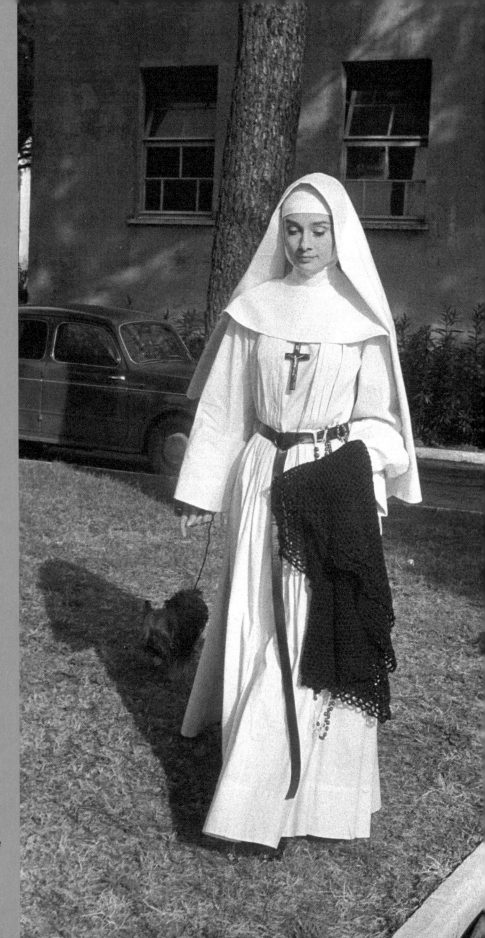

1958. Audrey in her costume as Sister Luke, the leading role in *The Nun's Story*, taking her dog for a walk in the gardens of Cinecittà.

1958. A still from the set of *The Nun's Story*.
After buying the rights to the bestseller by Kathryn Hulme, director Fred Zinnemann
found little enthusiasm in Hollywood for making the story into a film. Everything changed
when Audrey expressed the desire to play the main role, Sister Luke. This led to an auction
that was won by Warner Brothers, which then made the story into one of its most
acclaimed films and, ultimately, its most profitable film of 1959. The role was one of
Audrey's favorites, and her performance earned her a third Oscar nomination and won her,
among others, BAFTA and David di Donatello awards. Audrey met Marie-Louise Habets,
the nun who inspired the novel and the film, and they became close friends.
After Audrey had a near-fatal riding accident on the set of *The Unforgiven* (1960),
directed by John Huston, Habets nursed her back to health.

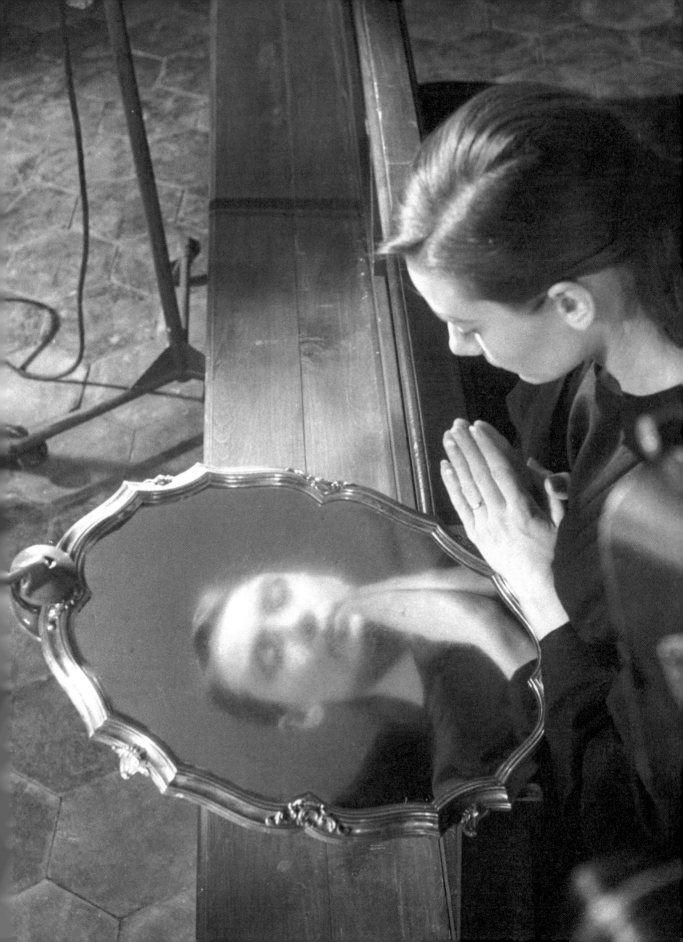

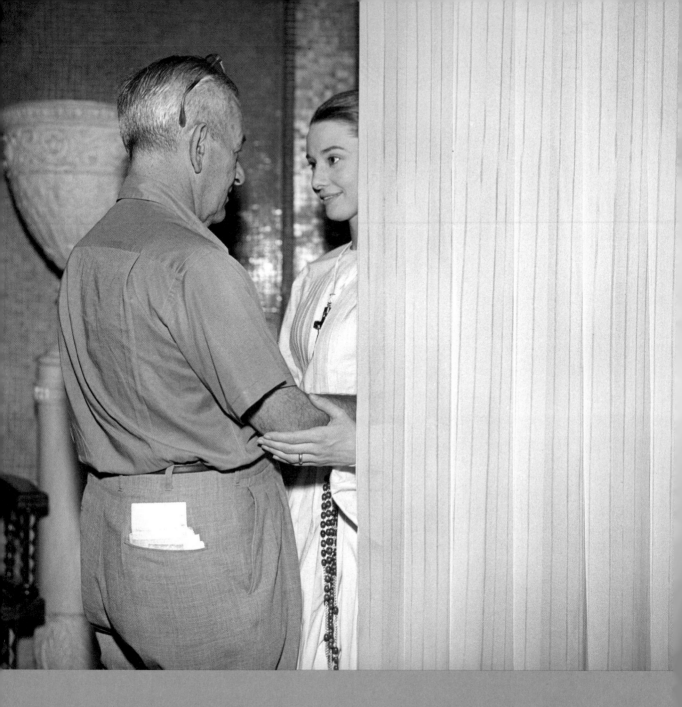

1958. Director William Wyler,
while filming the epic *Ben-Hur*,
visited Audrey at Cinecittà on
the set of *The Nun's Story*.

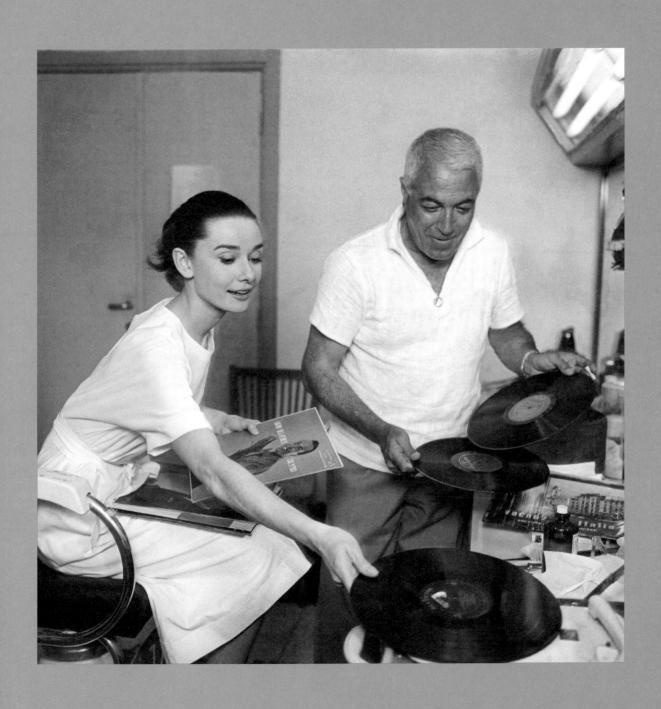

1958. Audrey with makeup artist
Alberto De Rossi.

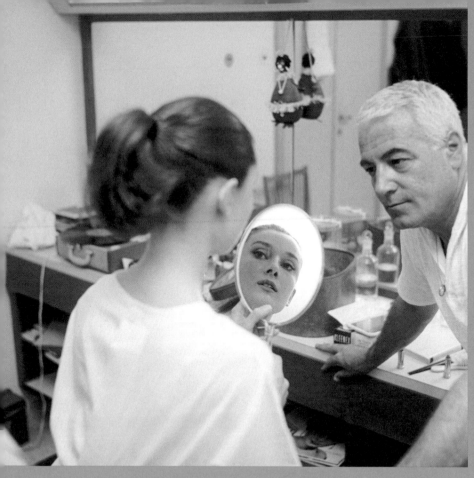

Alberto De Rossi, makeup artist to the stars, made Audrey's look famous. The wing eyebrows that followed the curve of her jaw, thus opening up her features, became a trademark of De Rossi's inimitable style.

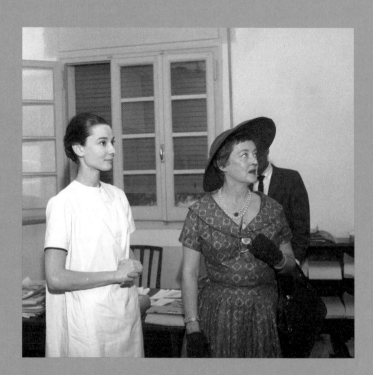

1958. Audrey with Bette Davis.

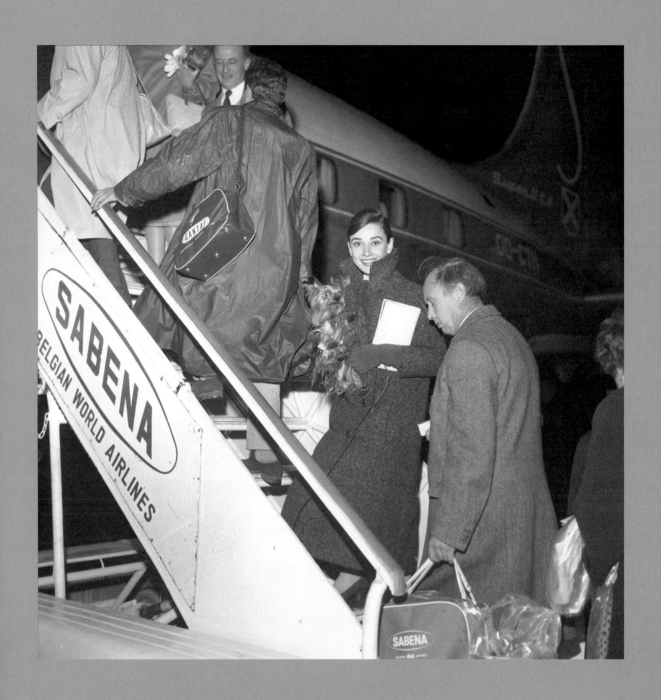

1958. Audrey departing for the Congo to continue the filming of *The Nun's Story*.

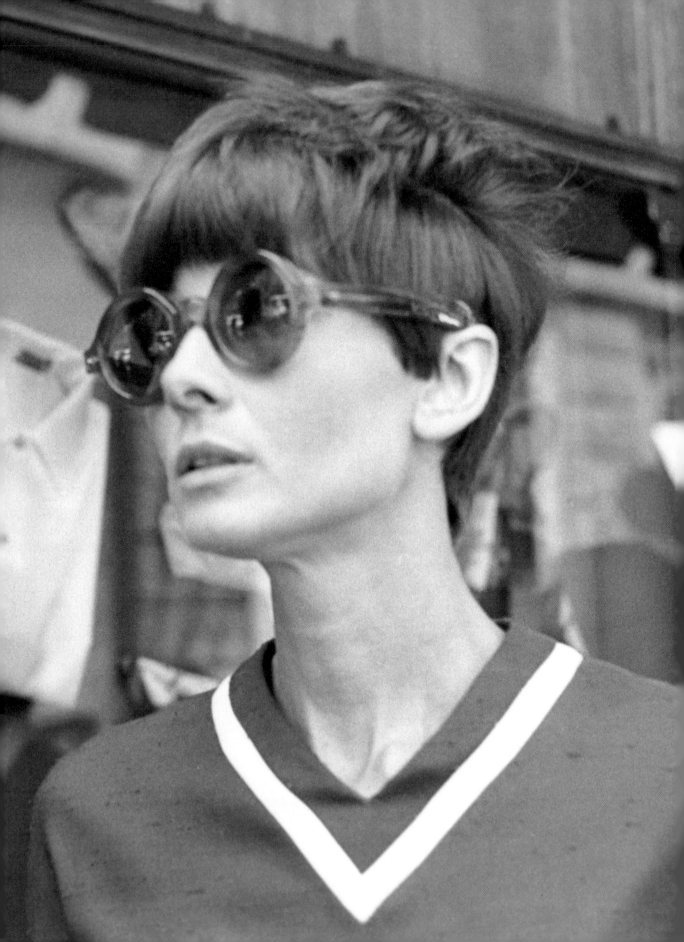

THE 1960s

On the fields of Woodstock as in the ateliers of Paris, style was cultivated by the young, whose excitement was contagious; in those years television brought the world closer, creating a blend of influences distant and different, unique and innovative. From Federico Fellini to John F. Kennedy, from the first moon landing to the songs of Mina, the 1960s was a decade full of discoveries, as well as moments of drama, courage, and rage.

After the success of *Breakfast at Tiffany's*, Audrey was at the height of her career, and her presence in Italy became even more frequent. She was a young wife, movie star, and mother. Rome followed her in these three roles with the ceaseless curiosity of someone who is also an accomplice. The star became less formal in her clothing style, trusting more and more in Givenchy, who created soft swing coats and wool bouclé suits with large buttons; she also appeared in the Roman jet set as a young woman in search of a normal life. These were years in which the White House—with Jacqueline Kennedy as its star—was as much a symbol of glamour as Hollywood was. These were also the years of the scandals and excesses of Elizabeth Taylor on the set of *Cleopatra* at Cinecittà. Audrey, however, remained the main attraction of the era, both on gala nights and at the most simple and ordinary moments.

During the early 1960s, Audrey continued to wear the sophisticated and eccentric linear style of Holly Golightly, her character in *Breakfast at Tiffany's*. She preferred black and wore her hair pulled into a chignon, even in private. With her slender figure and modest elegance, she stood out in sharp contrast to the voluptuous leading ladies of Italian cinema, such as Gina Lollobrigida and Sophia Loren, though she proved no less sensual and mysterious.

In the mid-1960s, fashion experienced a revolution. Along with the arrival of the miniskirt came the A-line silhouette for coats and dresses, prints by Emilio Pucci, and square-toed shoes—a look made even more eccentric by accessories such as oversize eyeglasses or a playful hat worn with a certain chic aloofness.

She was a Hollywood star, but at the time Audrey could just as easily have passed for a teenager at a Beatles concert, a first lady on an official visit, or a beautiful airline stewardess. She was instead a fashion icon of the most disciplined polish, full of passion, but never reckless or provocative: as such, Audrey was the ideal guest for a city like Rome, which never tired of her.

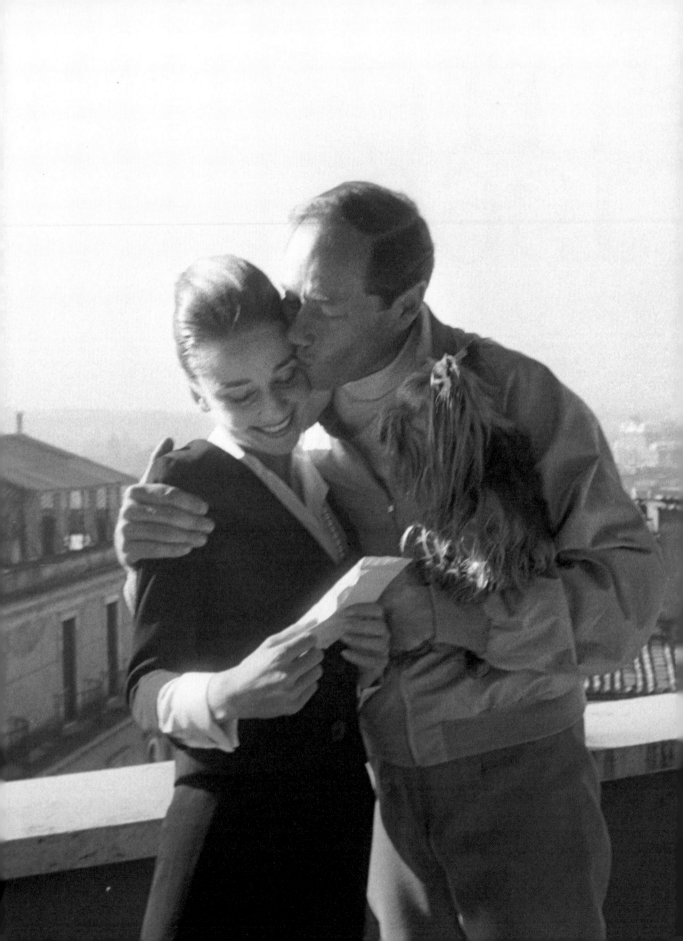

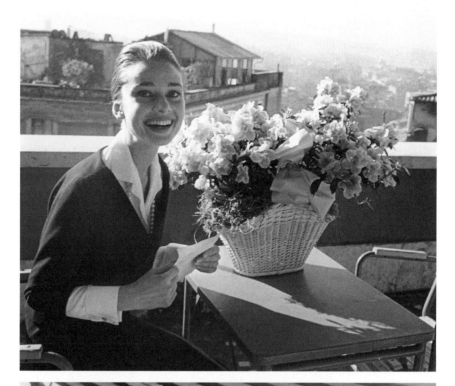

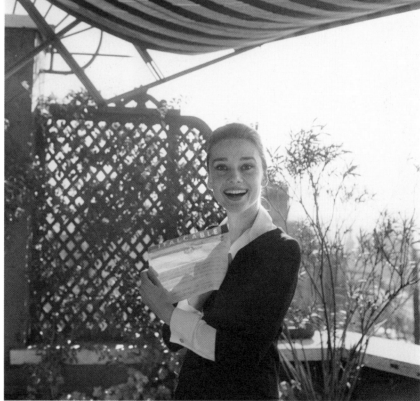

1960. With Mel Ferrer on the terrace of the Hotel Hassler. These images show her opening the telegram announcing her best actress award from the New York Film Critics Circle for *The Nun's Story*.

 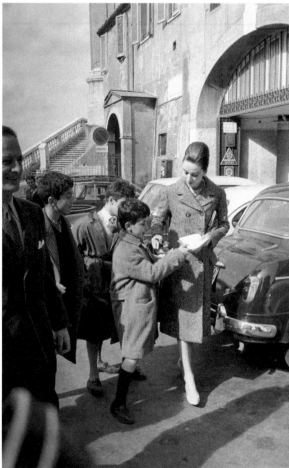

1960. Audrey at Trinità dei Monti, surrounded by young fans.

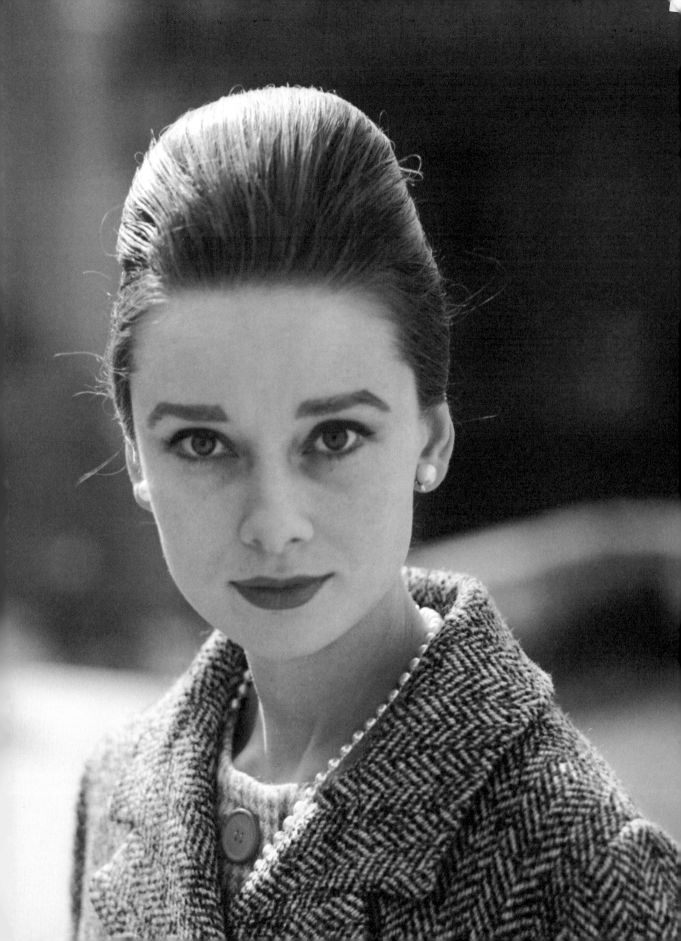

1960. Audrey and director
Fred Zinnemann posing for
pictures at Trinità dei Monti.

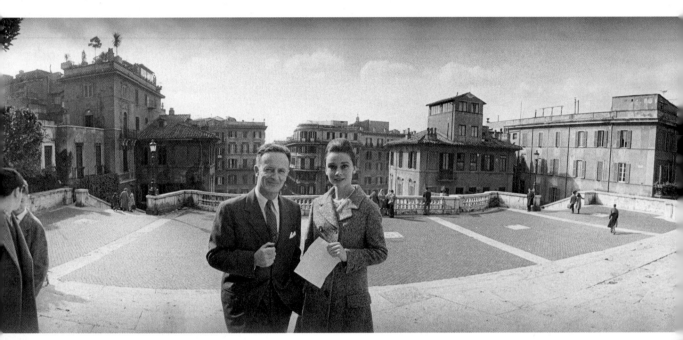

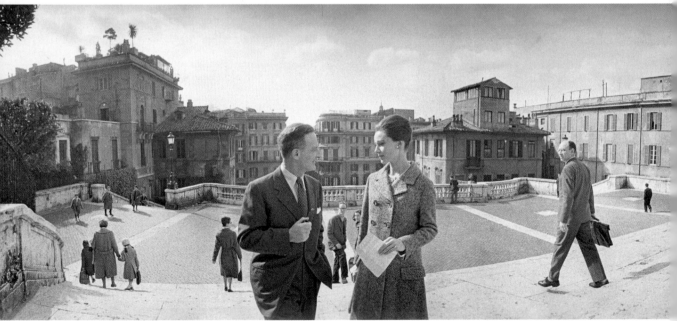

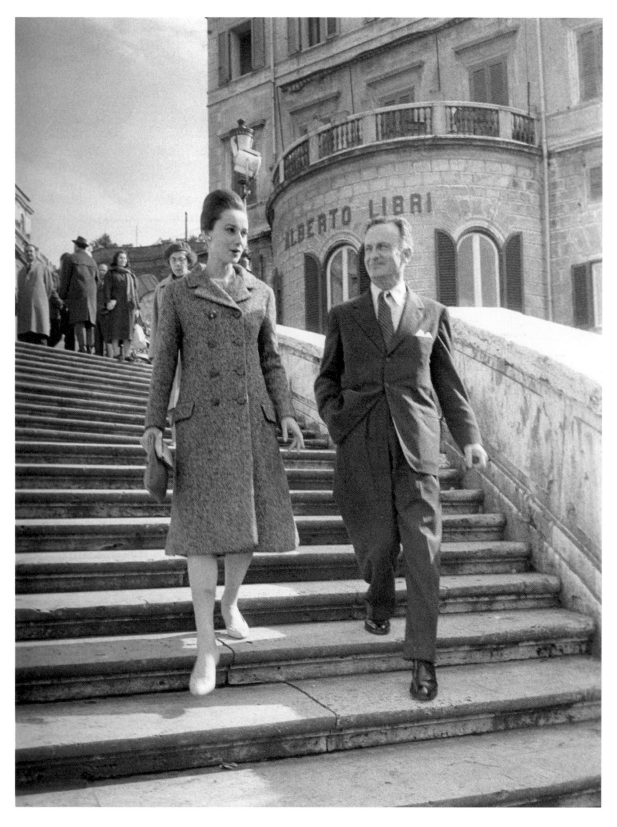

1960. Audrey and Fred Zinnemann on the Spanish Steps.

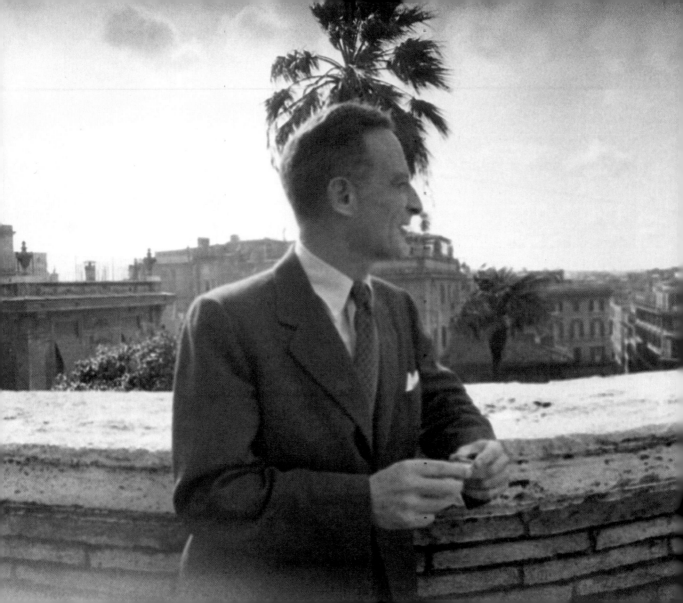

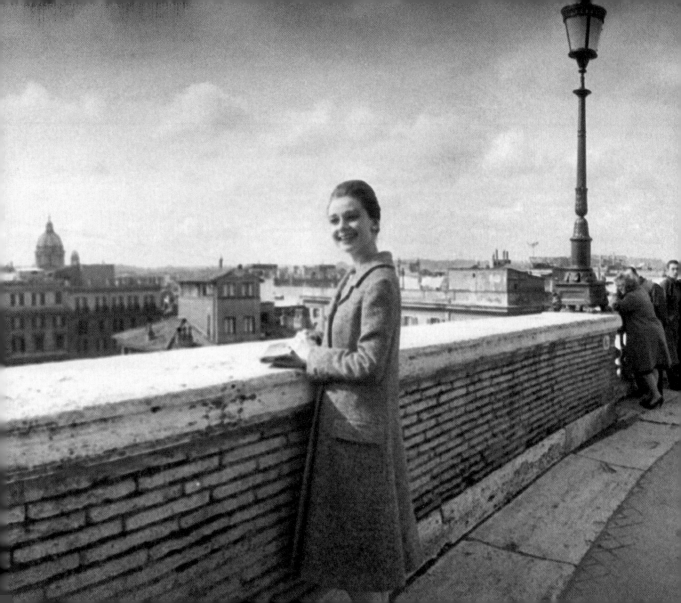

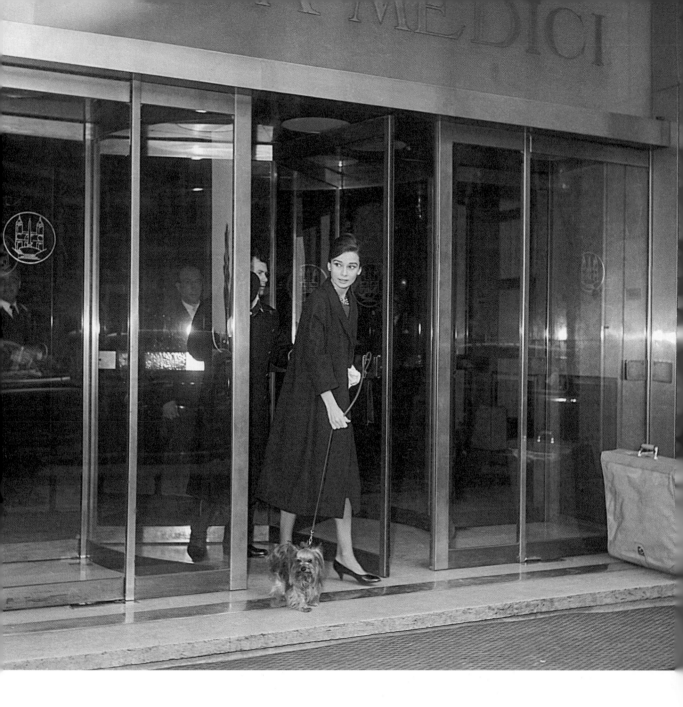

Above and opposite:
February 7, 1960. Audrey leaving the Hotel Hassler in Trinità dei Monti.

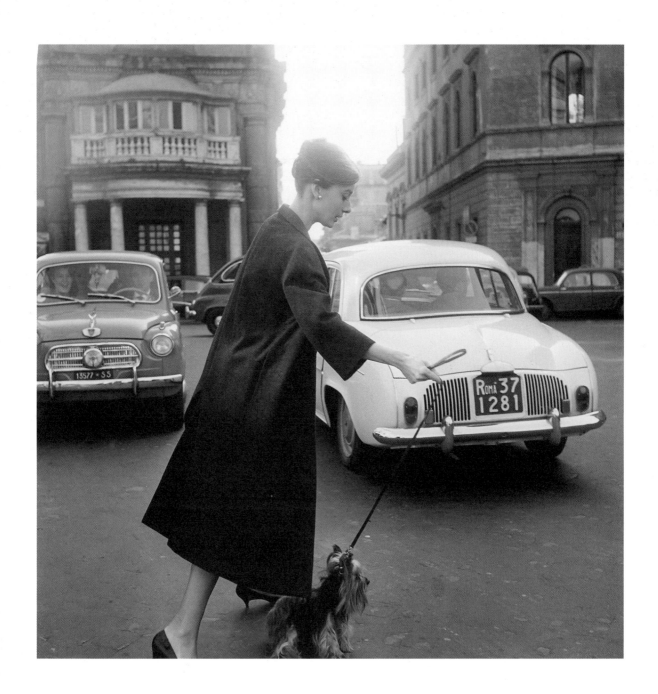

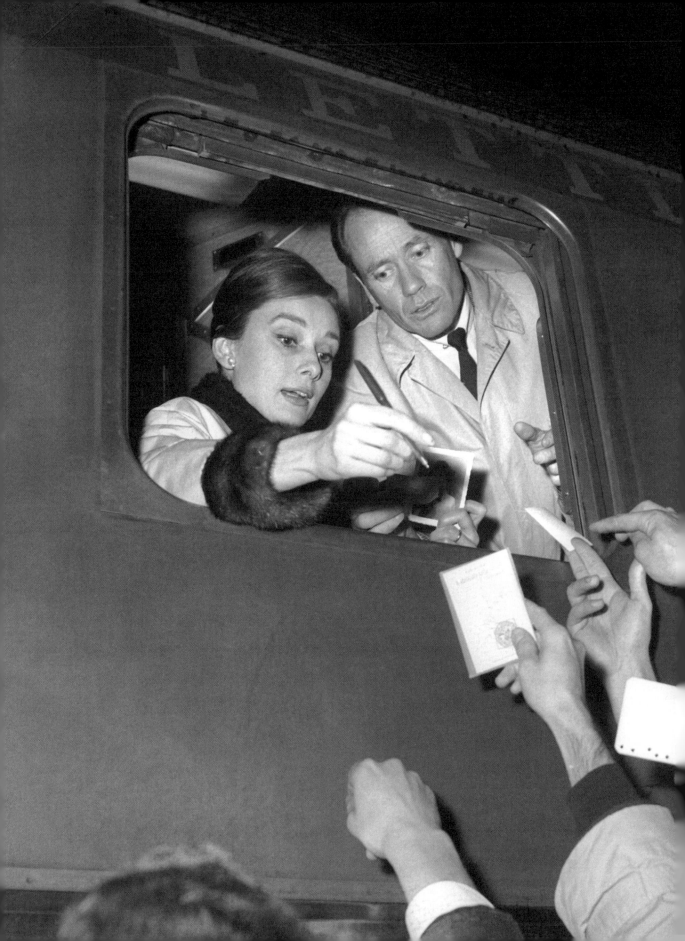

March 5, 1960. At Rome's Termini
train station, Audrey and Mel Ferrer,
departing for Switzerland, sign
autographs from the window of
their train and (*above*) accompany
their luggage.

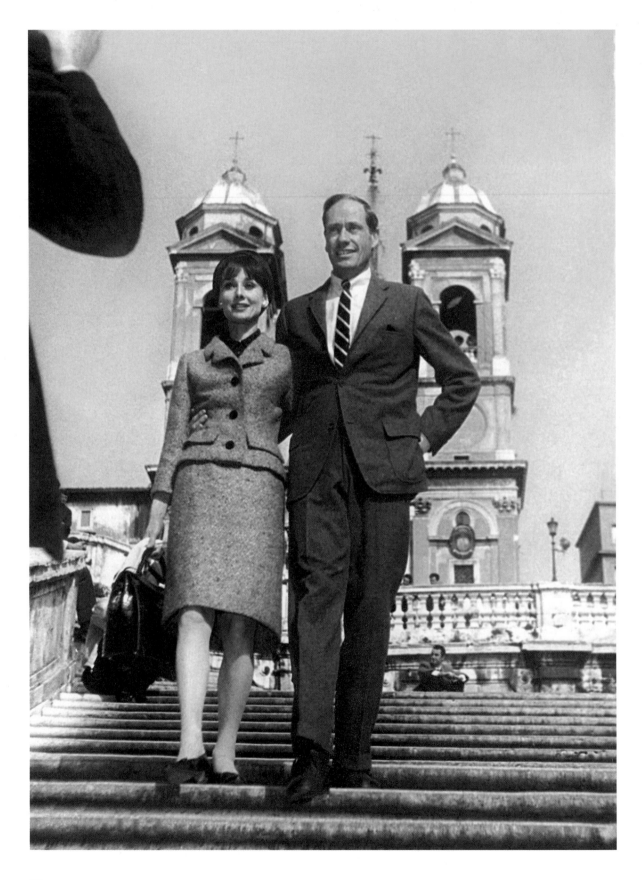

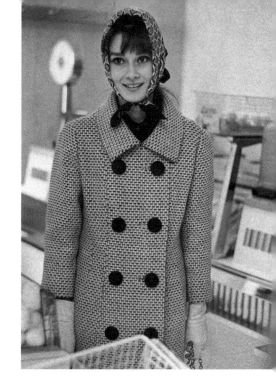

Opposite:
1960. With Mel Ferrer on the
Spanish Steps.

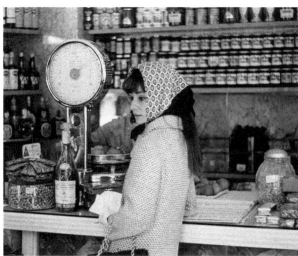

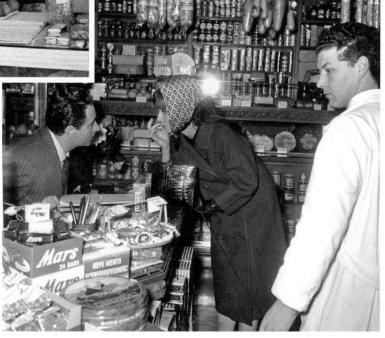

Circa 1960. Audrey shopping for
groceries. She loved to shop alone
in the little stores of the city, and
the citizens of Rome allowed her to
do so undisturbed.

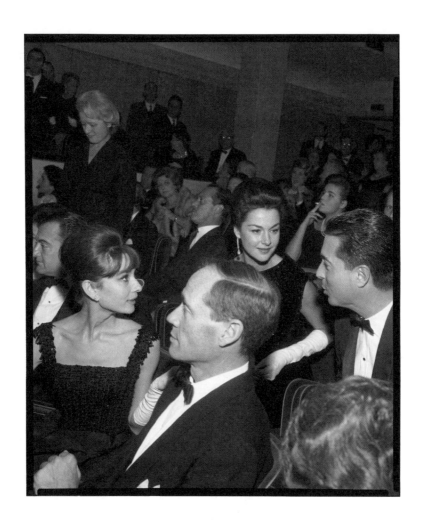

Audrey and Mel Ferrer at the premiere of *Breakfast at Tiffany's* at the Cinema Fiammetta with their friends Rudi and Consuelo Crespi.

LITTLE BLACK DRESS

Hubert de Givenchy's wardrobe for Audrey came to epitomize the new woman: refined, ironic, and intellectually provocative. With the release of *Breakfast at Tiffany's*, the black cocktail dress worn with pearls became synonymous with luxury and an international lifestyle, one that was at home on Fifth Avenue as much as on the Champs-Élysées. Neither overly severe nor overly risqué, the ideal little black dress was short, with few decorations, so that the neck and arms stood out. The outline was soft, like a brushstroke on the body, and the addition of white evening gloves made a discreet alternative to showy jewelry.

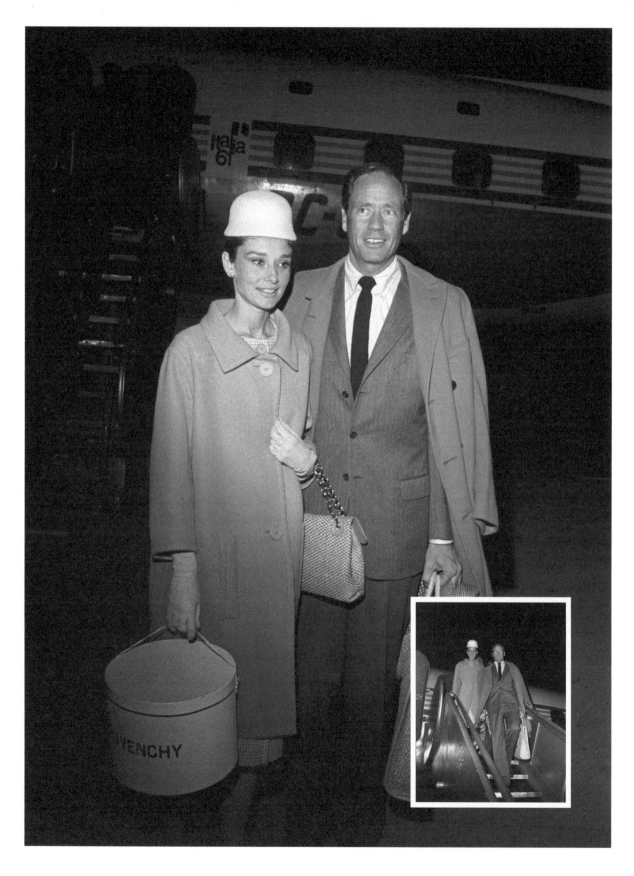

1961. Audrey and Mel Ferrer arrive at Fiumicino airport (*opposite and at right*). Audrey enters the Hotel Hassler (*below*).

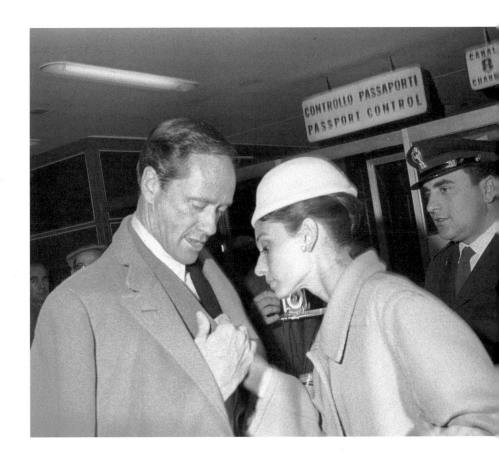

Audrey and Hubert de Givenchy's friendship was as timeless as their elegance. They first met in Paris in 1953 by pure chance. The young Audrey had gone to Balenciaga for costumes for *Sabrina*. The great couturier, unable to make time for the appointment, sent his favorite student in his place. Givenchy, happily expecting a visit from Katharine Hepburn, was surprised to see Audrey instead and exclaimed, "Who is this little girl?" Destiny thus set in motion a legendary collaboration between two artists that changed the laws of style forever.

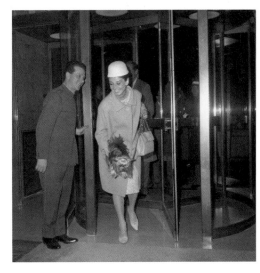

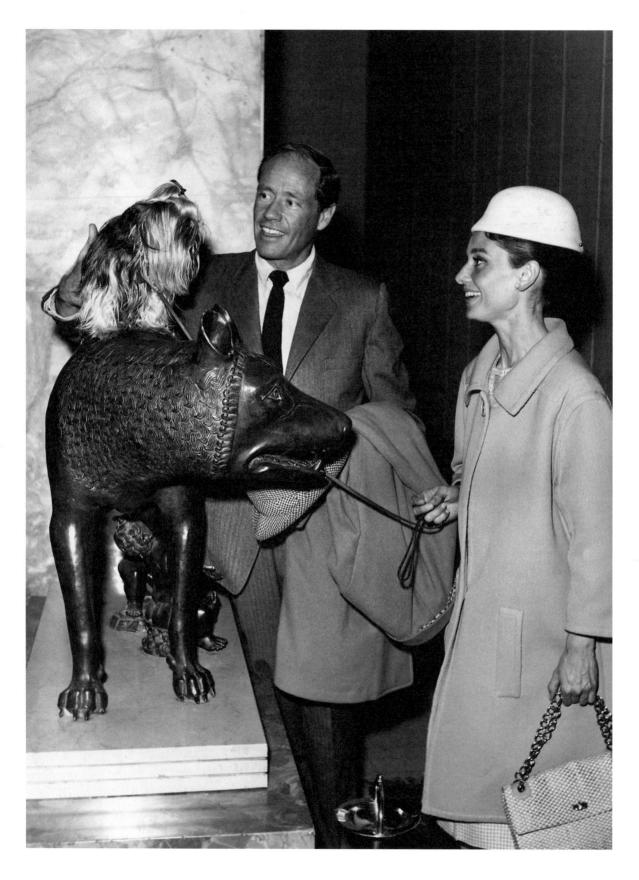

Opposite:
1961. Audrey and Mel Ferrer
with Mr. Famous, who sits atop
the *Lupa Capitolina*.

1961. Audrey with Mel Ferrer and
their son, Sean, leaving Ciampino
airport. Sean was a little over
one year old.

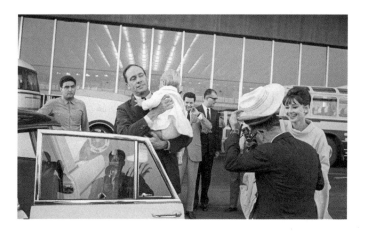

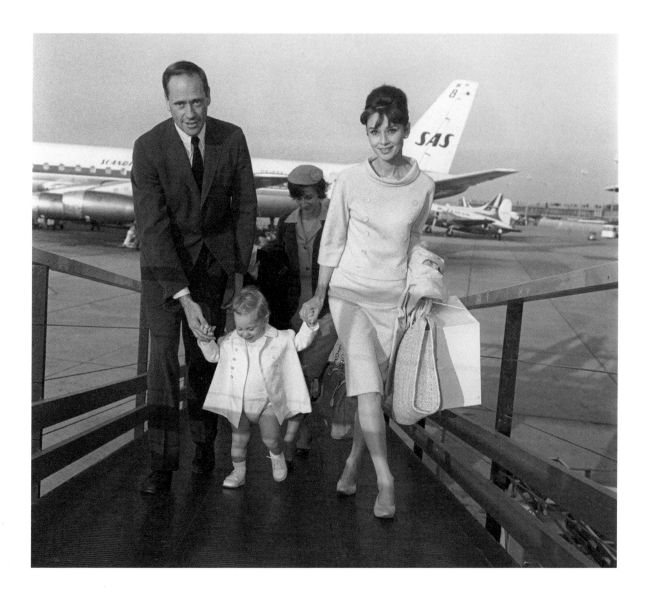

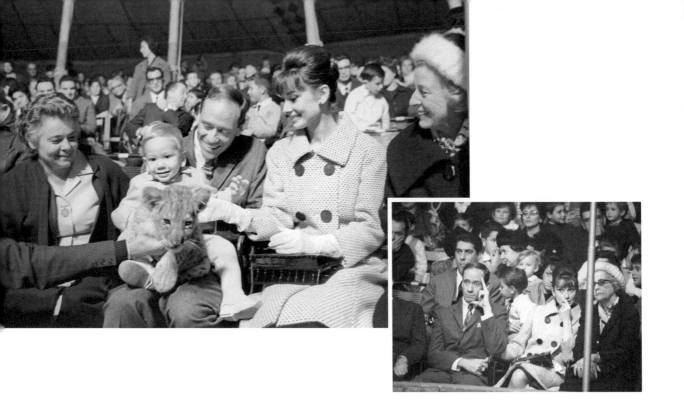

1961. With Mel Ferrer and
their son, Sean, at the circus.

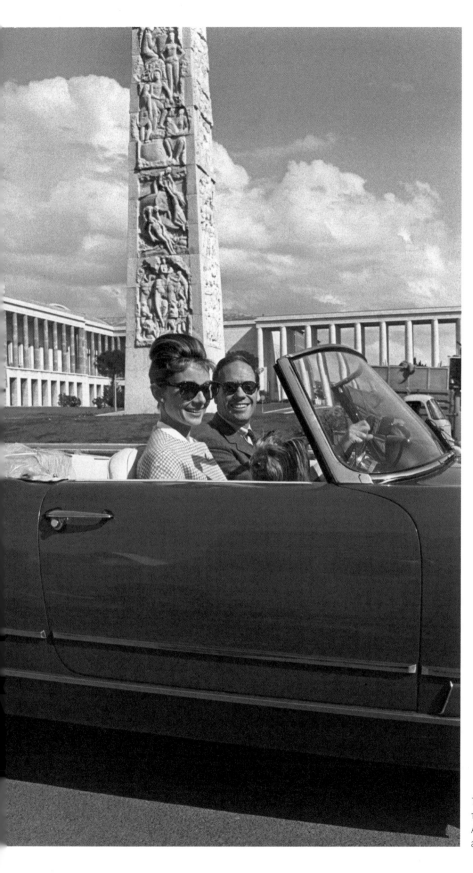

This page and the following pages:
1961. These posed shots present
Audrey and Mel Ferrer driving
around Rome's EUR district.

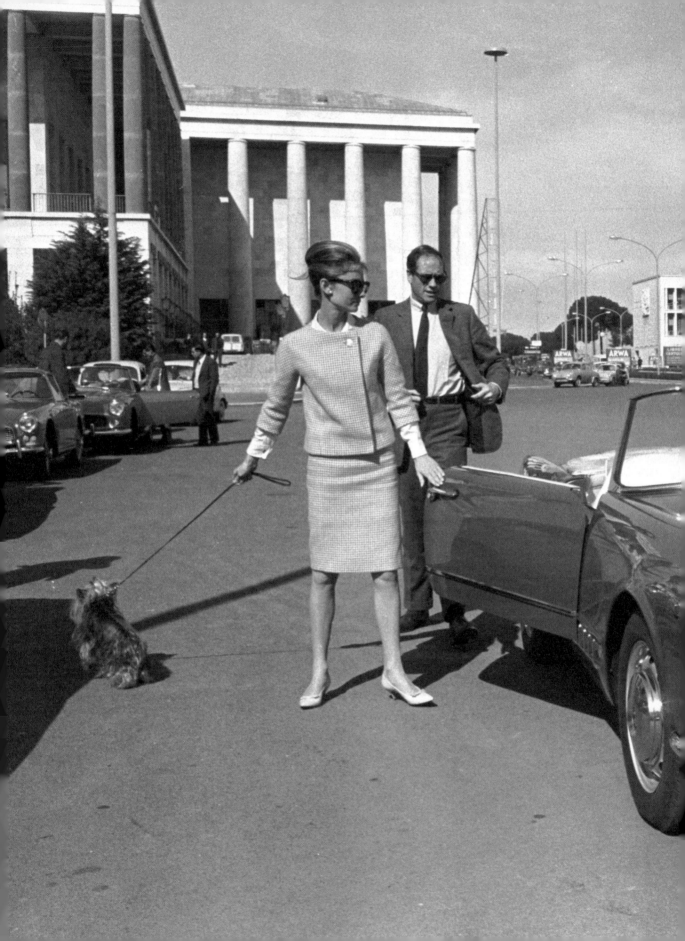

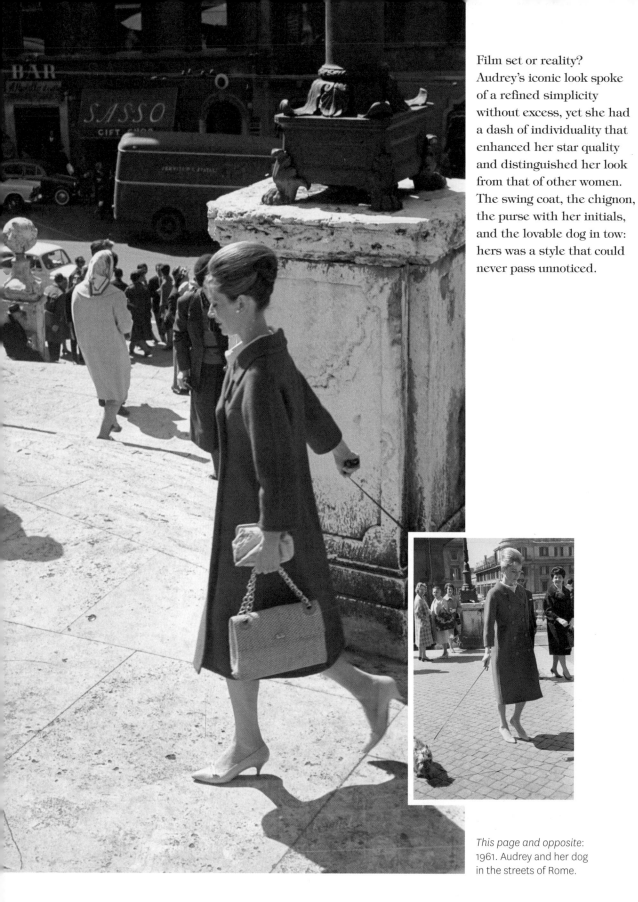

Film set or reality?
Audrey's iconic look spoke
of a refined simplicity
without excess, yet she had
a dash of individuality that
enhanced her star quality
and distinguished her look
from that of other women.
The swing coat, the chignon,
the purse with her initials,
and the lovable dog in tow:
hers was a style that could
never pass unnoticed.

This page and opposite:
1961. Audrey and her dog
in the streets of Rome.

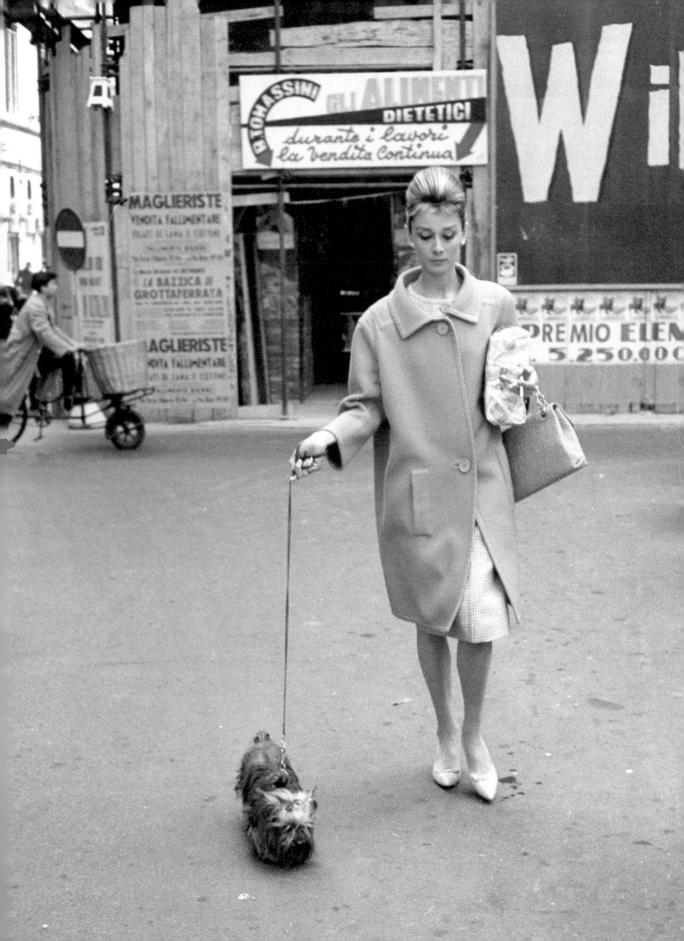

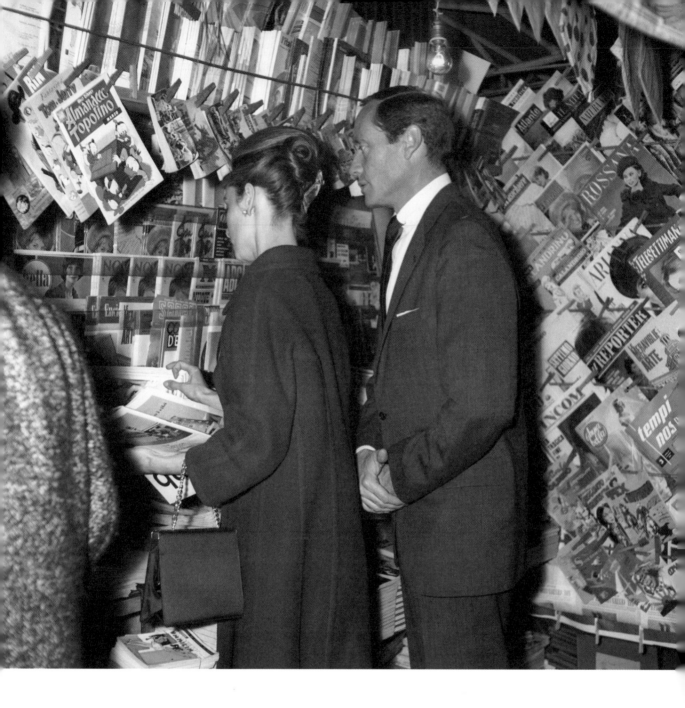

1961. Audrey and Mel Ferrer at a newsstand.

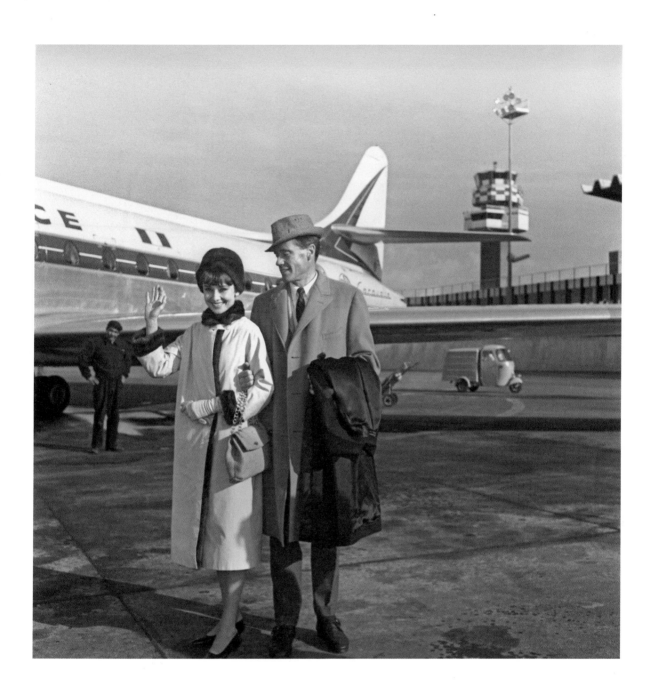

1961. Audrey and Mel Ferrer at Fiumicino, leaving for Paris.

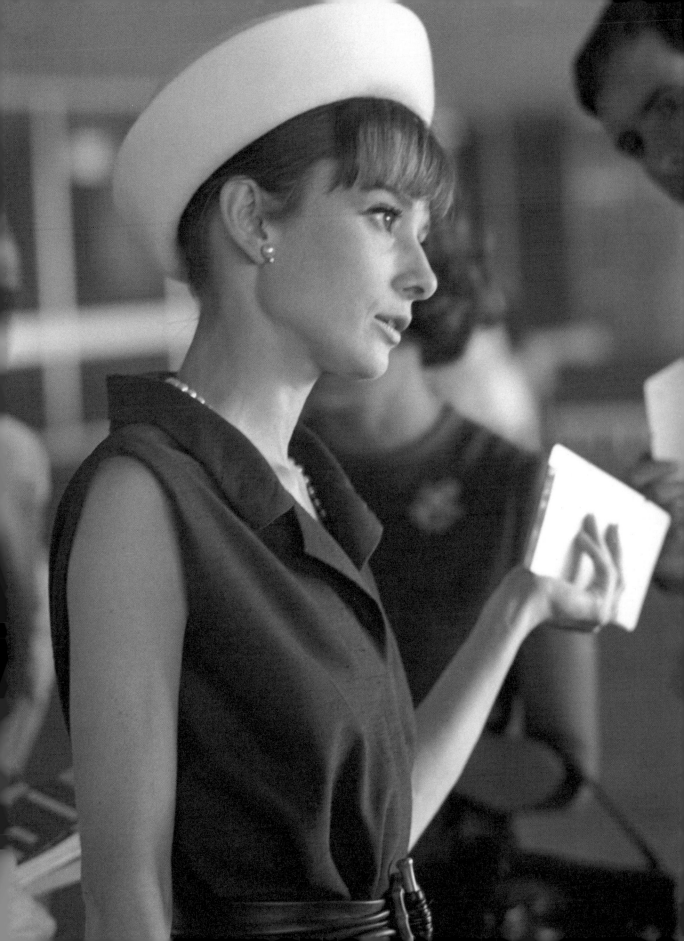

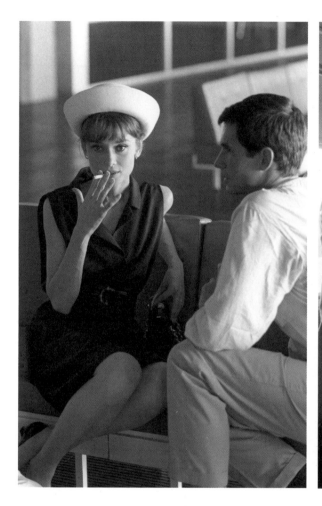

1962. With Anthony Perkins at Fiumicino airport.

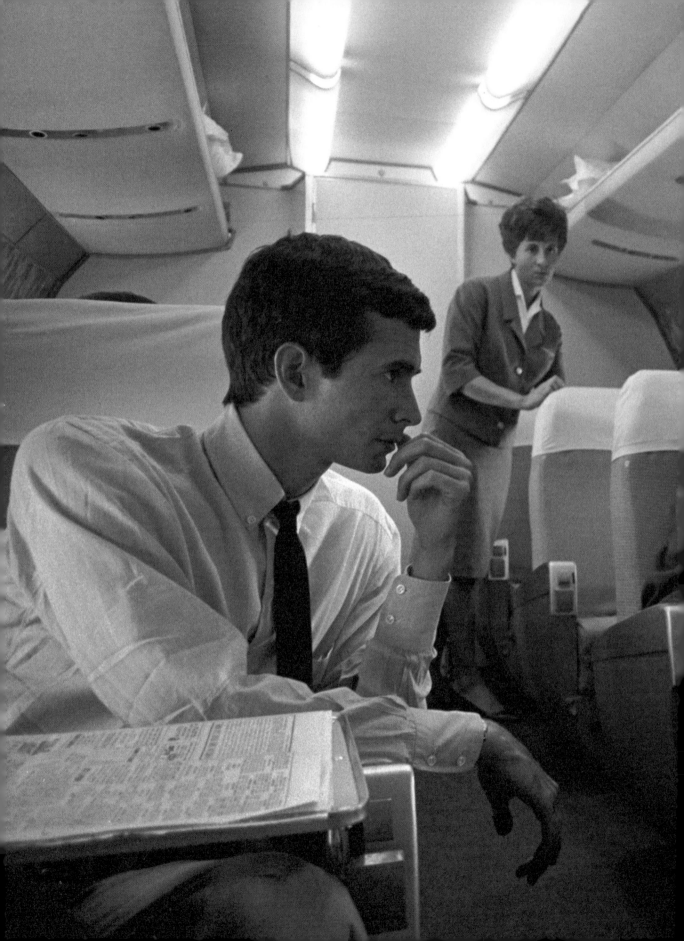

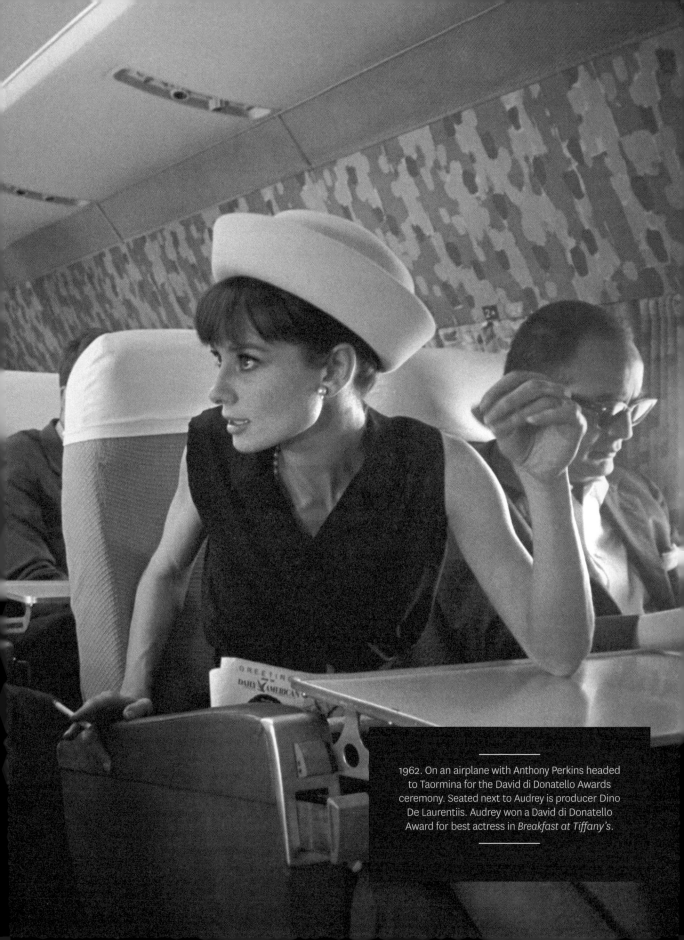

1962. On an airplane with Anthony Perkins headed to Taormina for the David di Donatello Awards ceremony. Seated next to Audrey is producer Dino De Laurentiis. Audrey won a David di Donatello Award for best actress in *Breakfast at Tiffany's*.

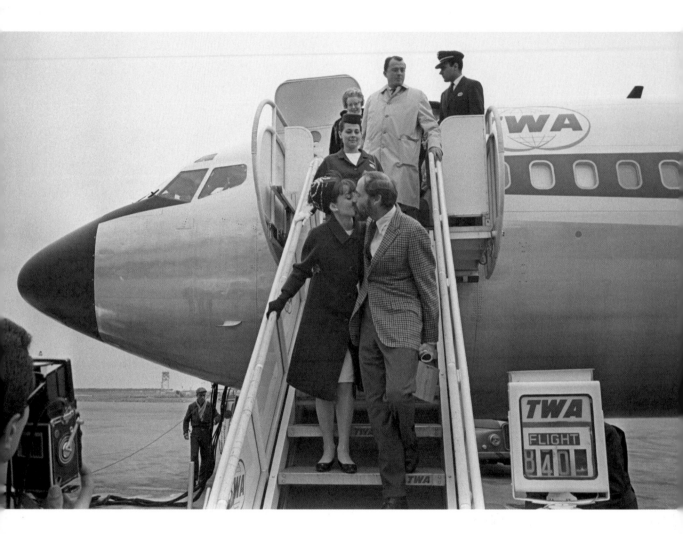

1964. *Below and opposite,*
with Mel Ferrer at Rome's
Fiumicino airport.

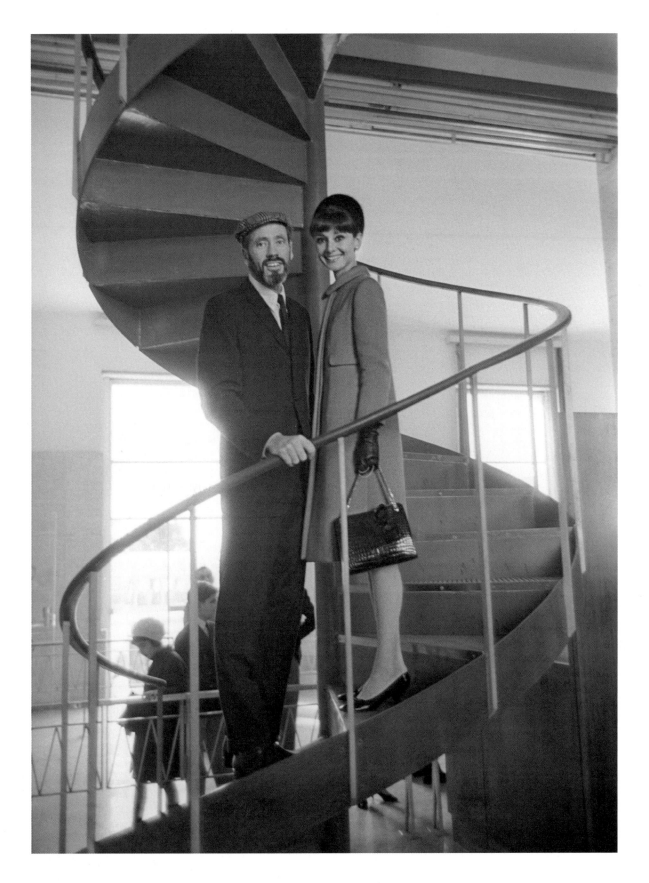

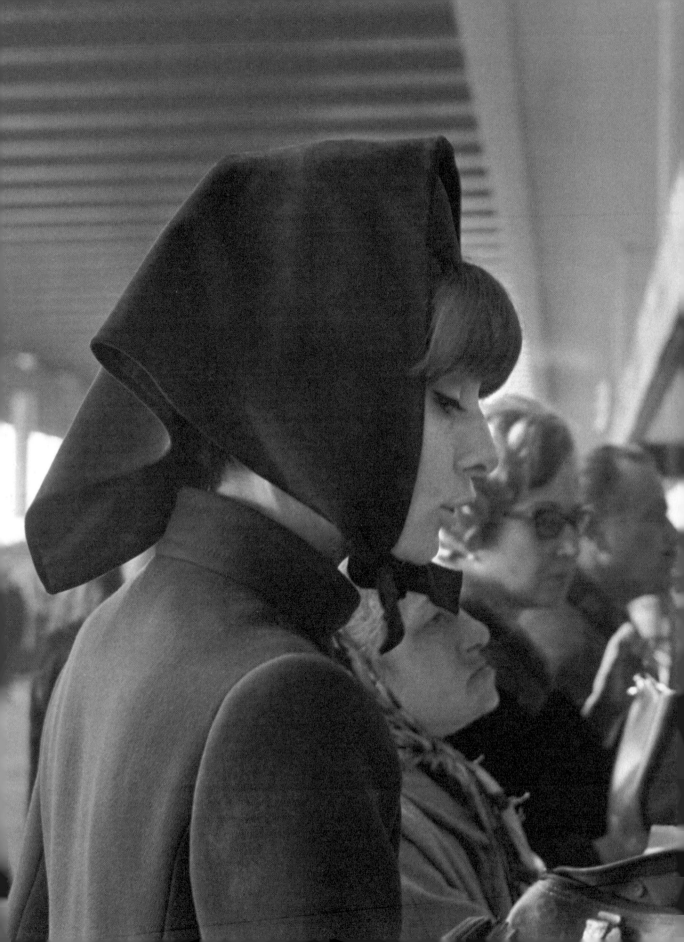

When she traveled, Audrey
had a uniform of sorts that
often incorporated an ethnic
element, typical of the 1960s.
Here Audrey wears a head-
scarf over a pillbox hat; the
scarf is made of the same
fabric as the triangular coat
with brass buttons. The vaguely
space-age style encapsulates all
the innovations of the decade.

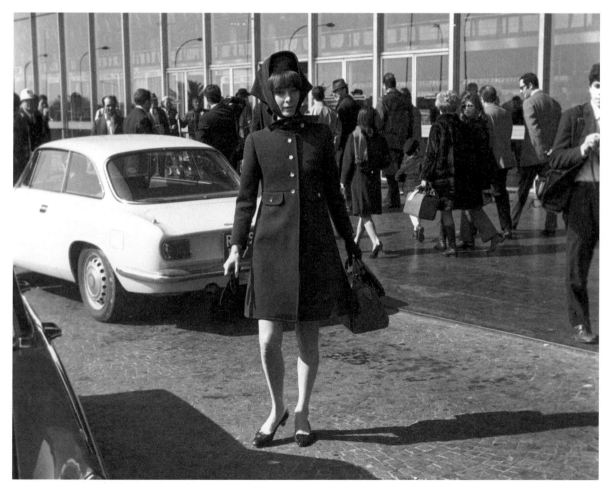

1966. Audrey at Fiumicino airport.

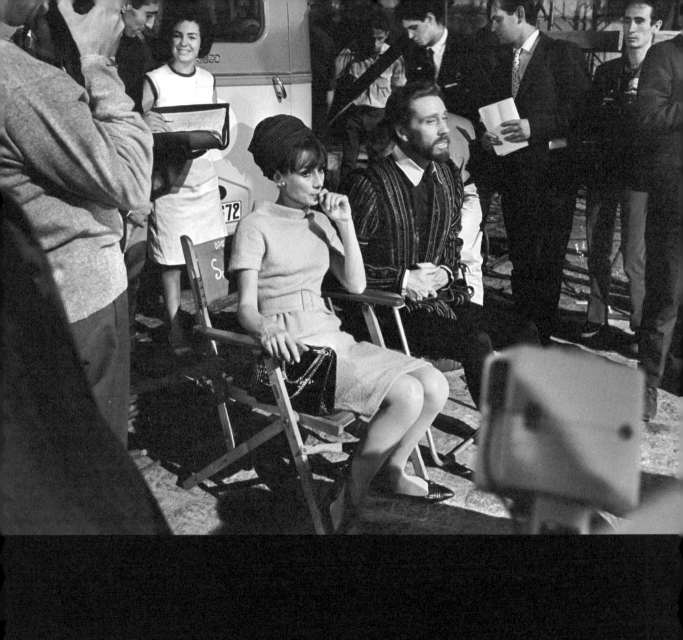

1966. Audrey at Cinecittà with Mel Ferrer on the set of *El Greco*, directed by Luciano Salce, in which Ferrer had the lead role.

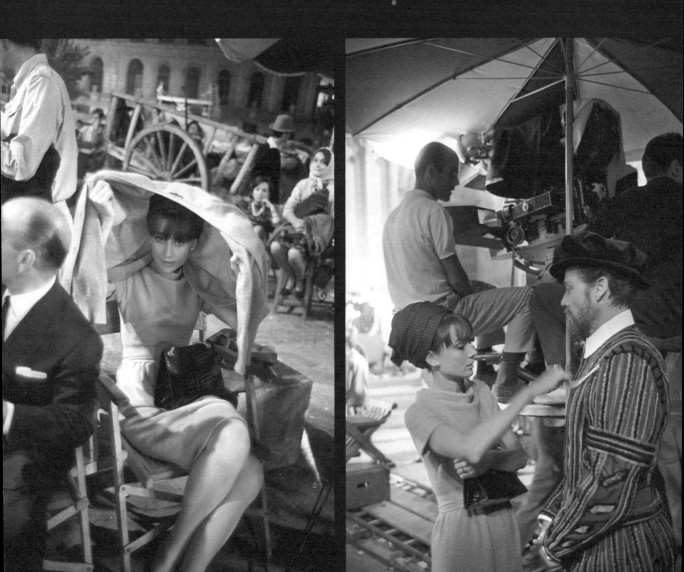

1966. Audrey with her friend
Lorian Franchetti Gaetani
in Piazza di Spagna.

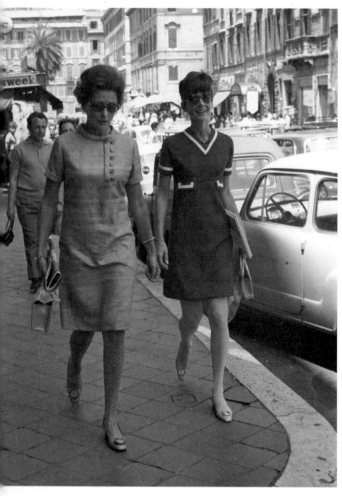

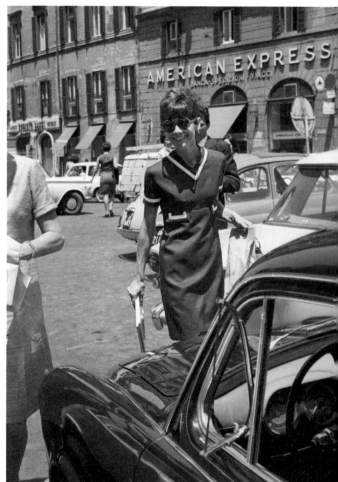

The nostalgic 1960s.
Getting out of a small
Fiat, wearing flats by
René Mancini and a
dress with tennis-stripe
accents, Audrey appears
to be an Italian woman
like any other.

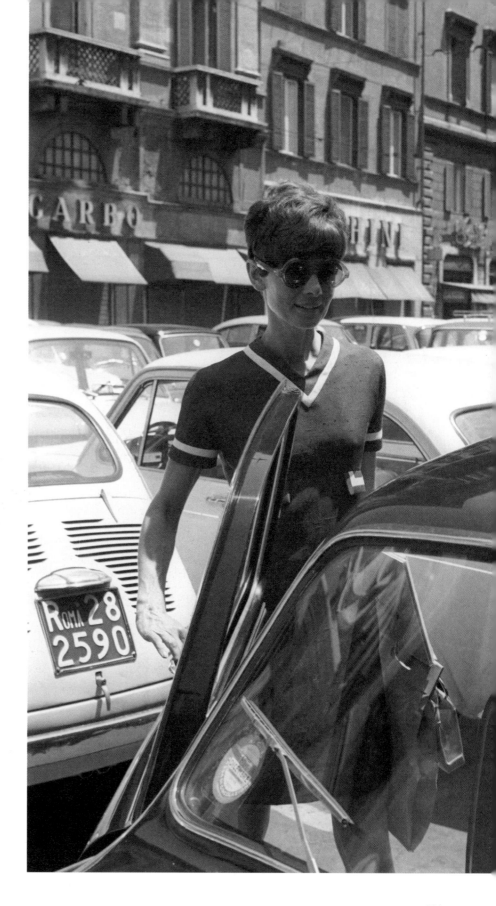

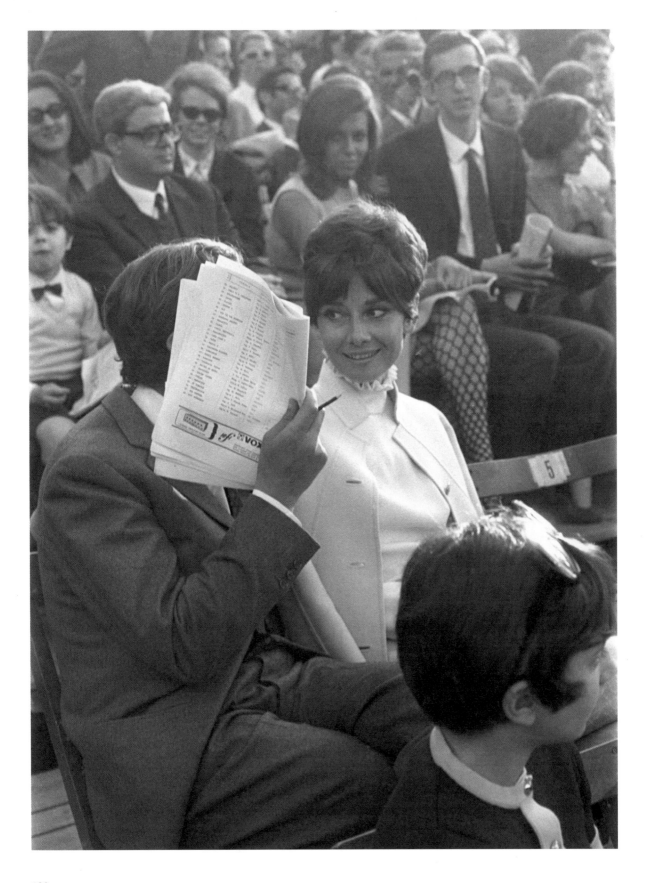

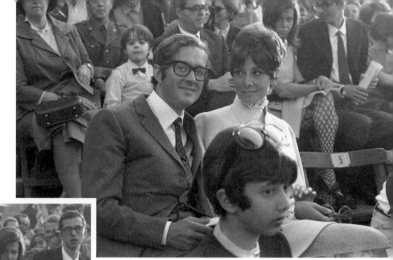

1969. Audrey with her second husband, the Roman psychiatrist Andrea Dotti, in Piazza di Siena.

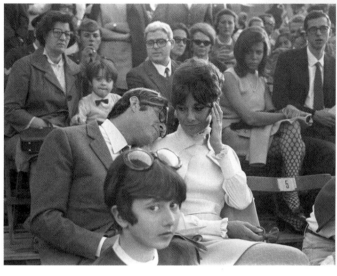

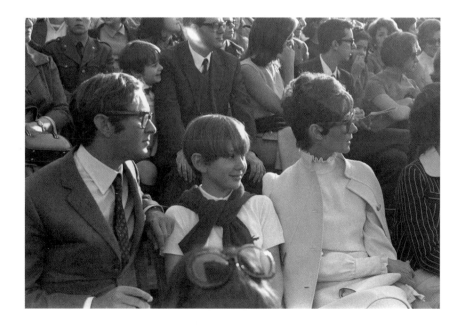

1969. The couple joined by Audrey's first son, Sean Ferrer.

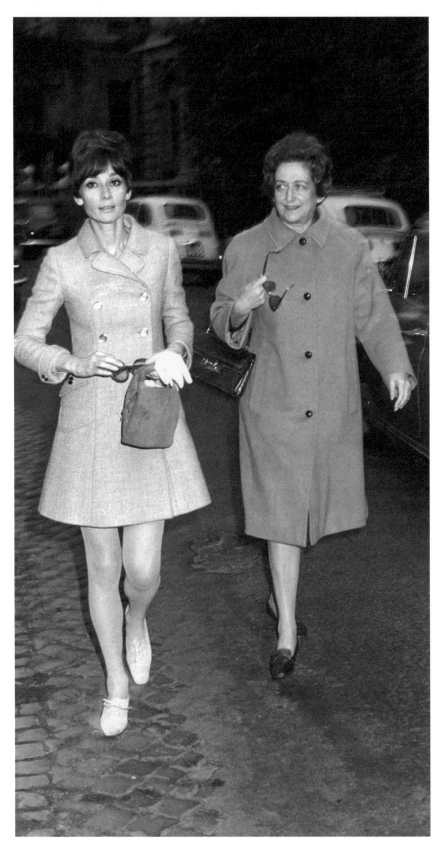

1969. Audrey walking in Rome with her mother-in-law, Paola Bandini.

Opposite:
Audrey passing by one of Rome's many flower stalls.

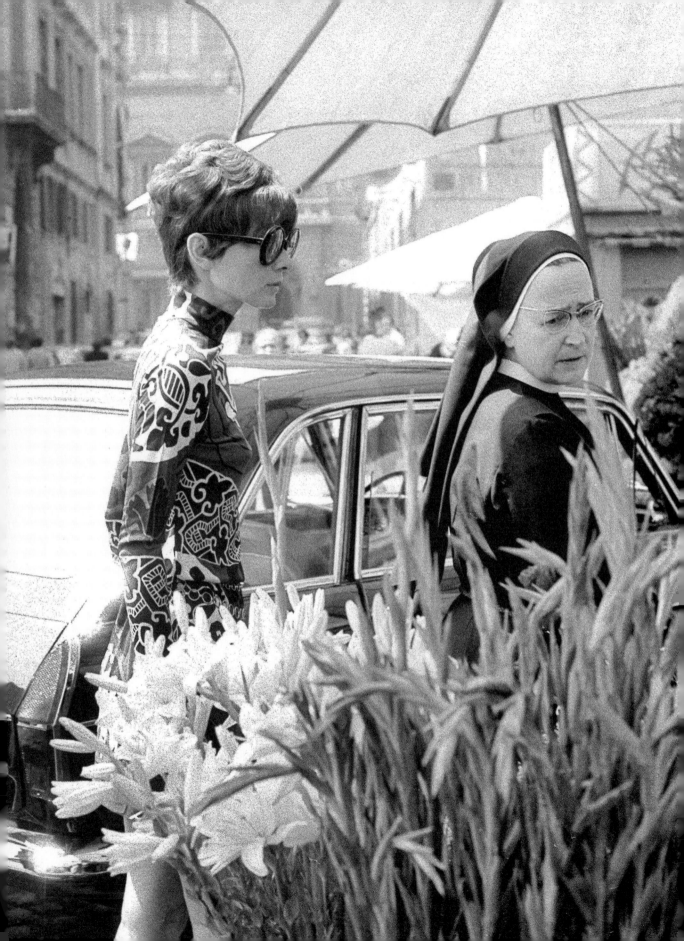

The 1960s were the years of the miniskirt, white stockings, and oversize glasses. Like Jackie O. and Twiggy, Audrey was a symbol of a changing generation in search of a new, freer femininity.

1969. Audrey on Via Borgognona with her friend Doris Brynner, wife of actor Yul Brynner.

Opposite:
1968. Audrey on Via Bissolati.

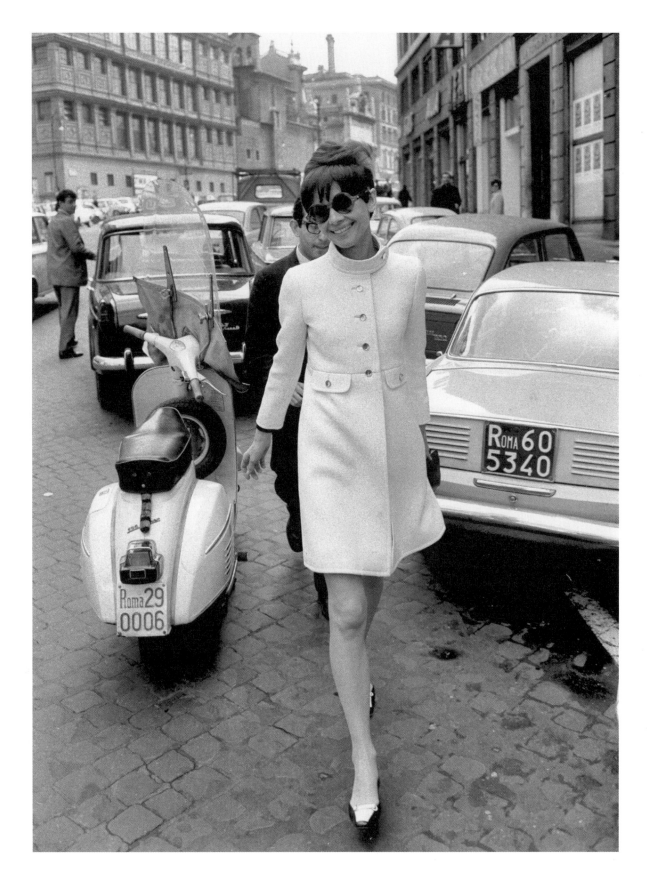

In the Spotlight

Premieres, gala evenings, and official award ceremonies were real work for actors and could sometimes be more demanding than actually performing in front of the camera.

Audrey always played her part perfectly in public, both on the occasions that concerned her directly, such as openings of her films, and on those in which she was only a participant. Her presence and her style always drew attention from both photographers and guests. Rome embraced her with open arms, making every one of her appearances a treasured event.

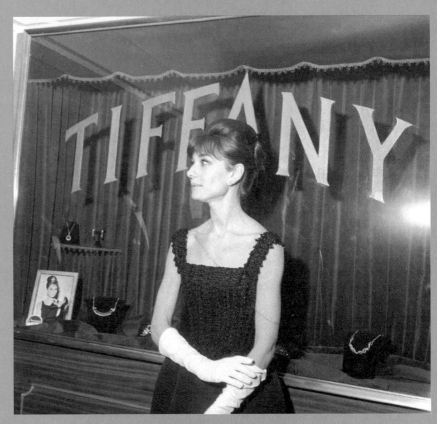

1961. *Above*, Audrey is shown with the Torlonia family, the Infanta Beatriz and Marino. *At right*, Audrey at the *Breakfast at Tiffany's* premiere at Cinema Fiammetta.

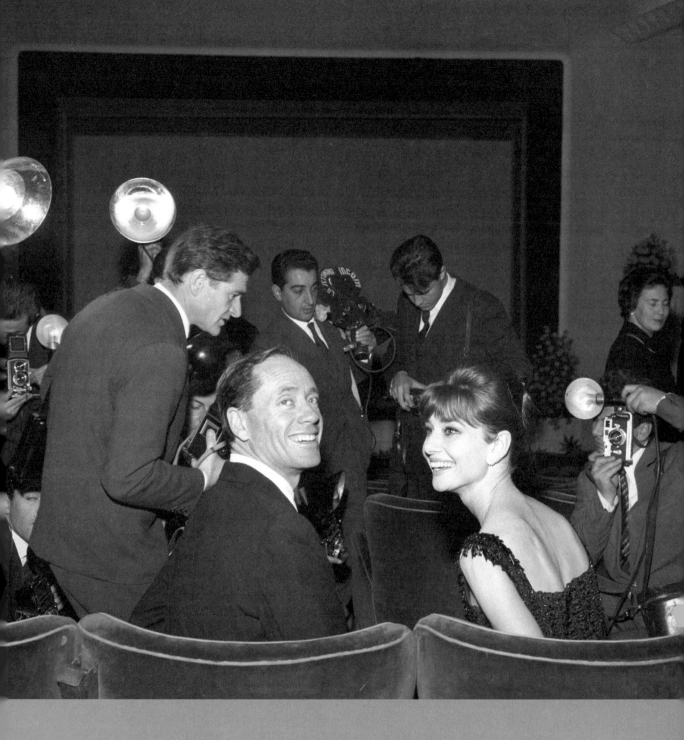

1961. Audrey and Mel Ferrer surrounded by photographers.

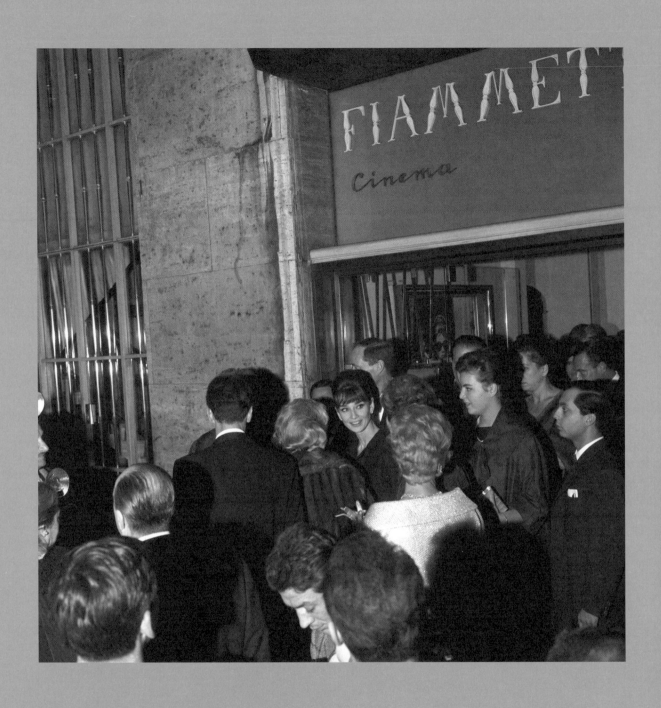

1961. Leaving the Cinema Fiammetta after the screening of *Breakfast at Tiffany's*.

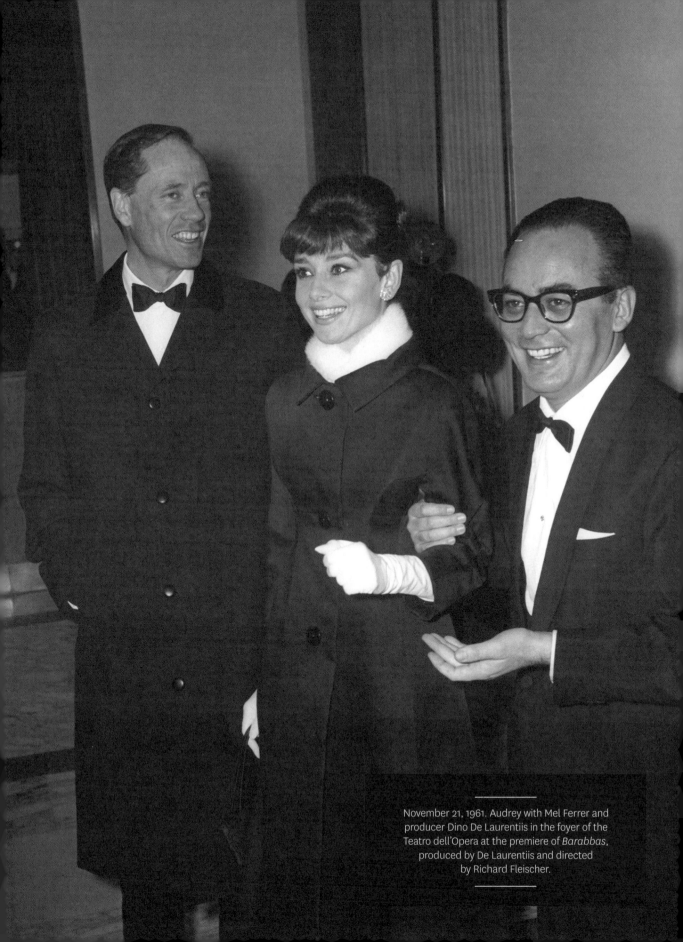

November 21, 1961. Audrey with Mel Ferrer and producer Dino De Laurentiis in the foyer of the Teatro dell'Opera at the premiere of *Barabbas*, produced by De Laurentiis and directed by Richard Fleischer.

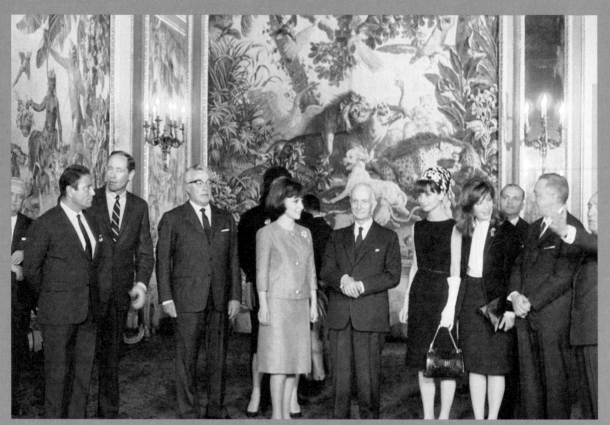

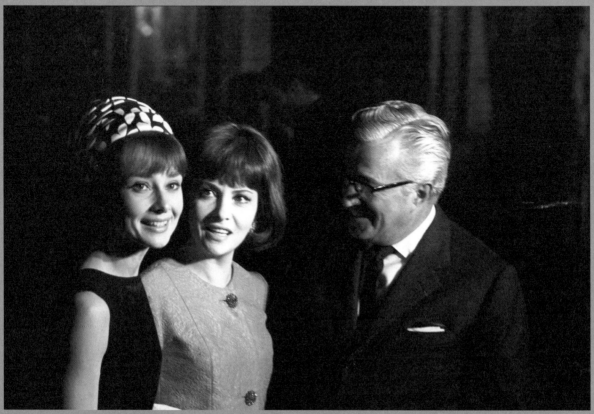

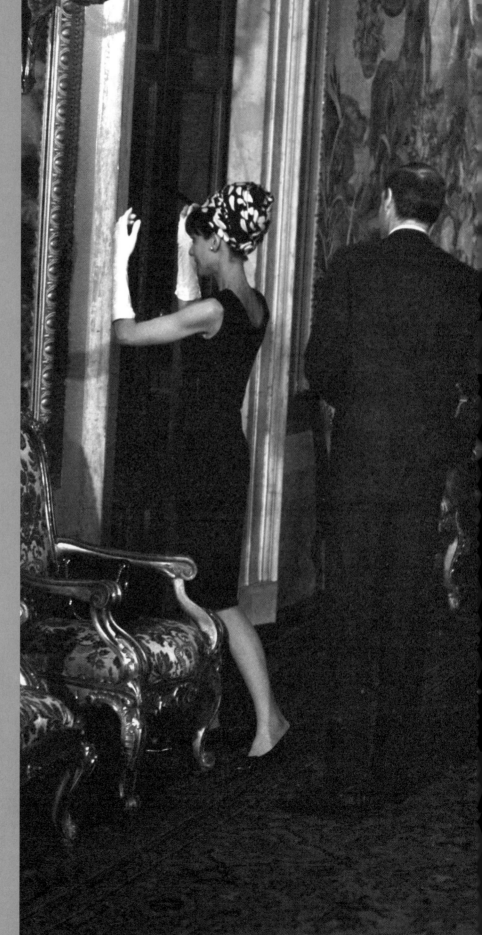

1964. It is customary for Italy's president to meet with the winners of the David di Donatello Awards. *Opposite, above*, President Antonio Segni is shown with (*left to right*) Raf Vallone, Mel Ferrer, Vittorio De Sica, Gina Lollobrigida, Audrey, and Monica Vitti. *Below*, Audrey with Gina Lollobrigida and Vittorio De Sica. *At right*, Audrey adjusting her hat in a mirror.

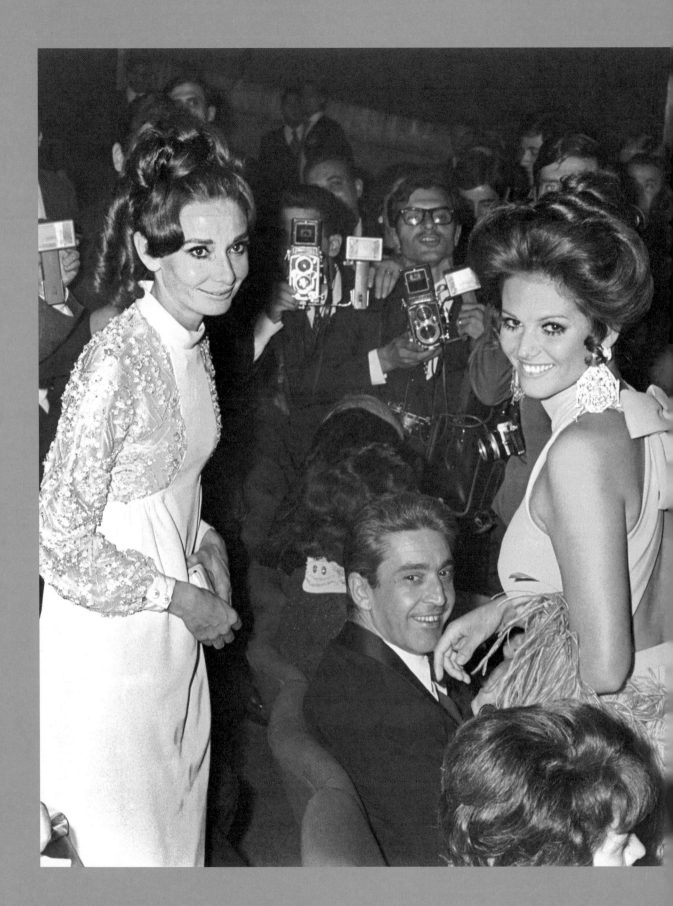

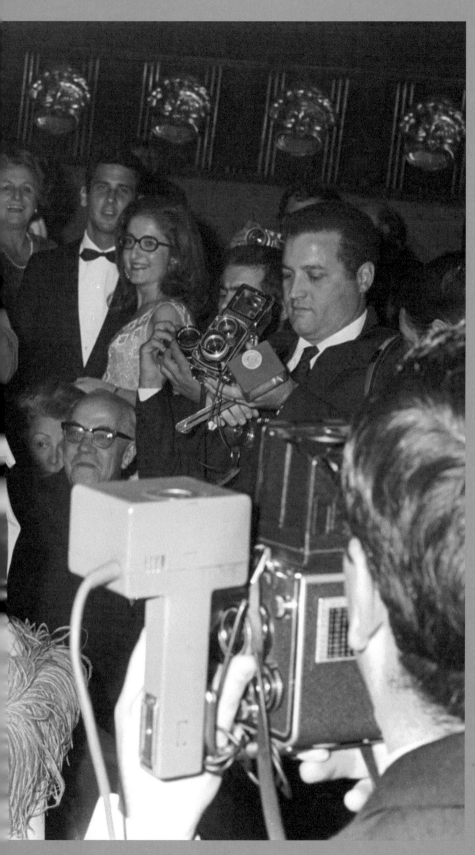

1968. Audrey and Claudia Cardinale at the Teatro Sistina for the Maschere d'Argento ("Silver Masks") award presentations. The awards are given to prominent individuals within the entertainment, fashion, and sport industries.

1968. Audrey with actress
Valentina Cortese at the awarding
of the Maschere d'Argento
awards. Ernest Borgnine is
visible below them.

Opposite:
1968. Audrey on her way to
a masquerade ball.

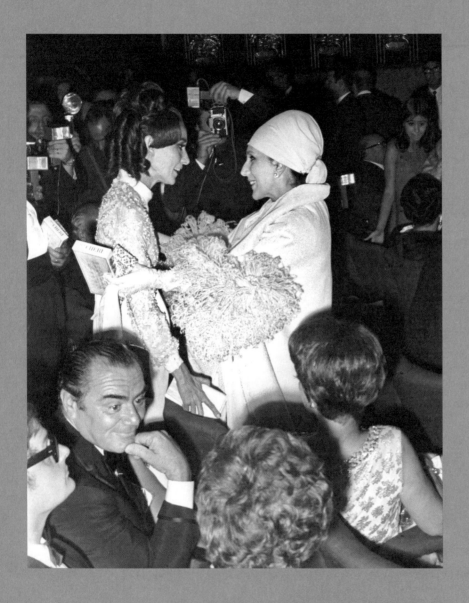

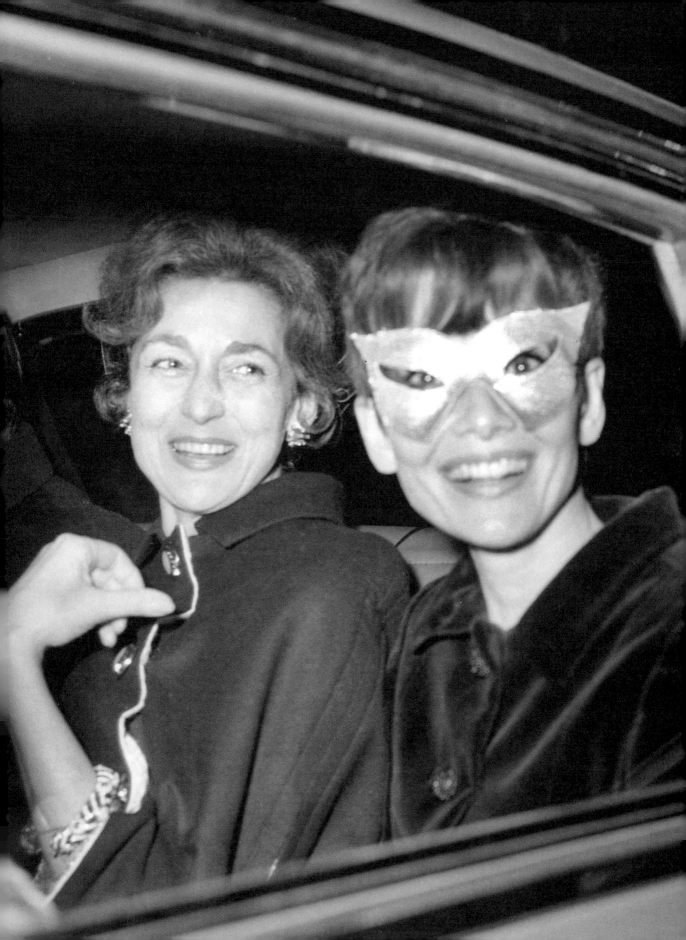

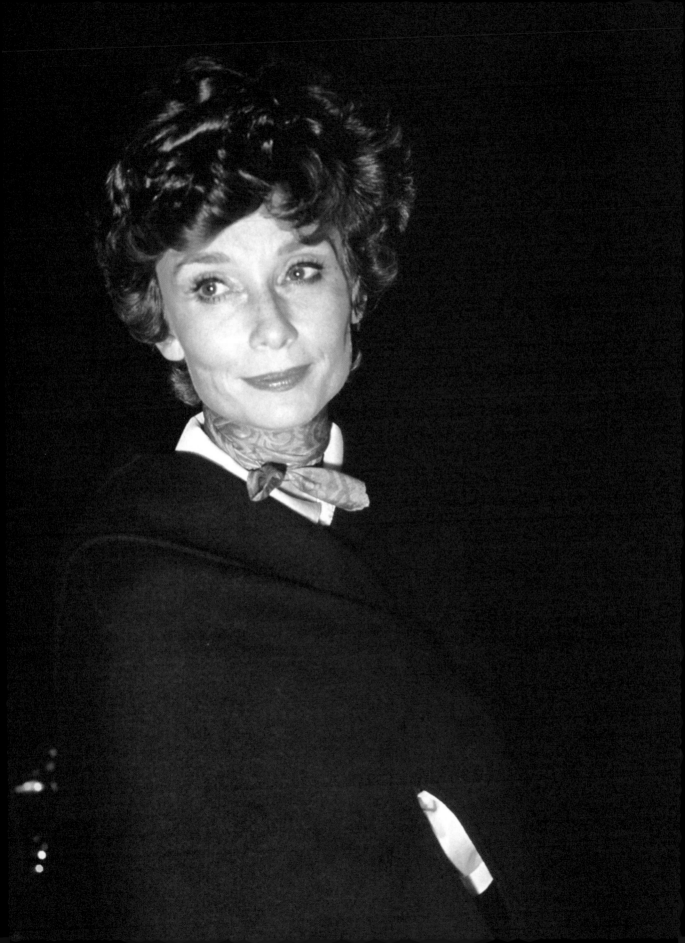

THE 1970s

For Audrey, the 1970s began with changes in her career and personal life, including a new marriage and the birth of her second son, Luca. She set aside her career to live in Rome and dedicate herself to her family. Offers of work came her way constantly, but she was determined to remain focused on her family. She didn't seem to care if the spotlight turned away from her, for in Rome she had her own cherished social life, with close friends such as Olimpia Torlonia and Doris Brynner. Audrey enjoyed going shopping in local stores, having leisurely Sunday lunches with her mother-in-law, and attending an occasional party—all key elements of her private life, which she embraced after an intensely public career.

In the images of Audrey taken during this decade, it is clear she is no longer a young girl but rather a fashionable woman who feels no need to emulate those figures who made certain styles famous. She was content to play herself, dressing in clothes that ranged from the hyperfeminine to the androgynous, fully in keeping with the most refined ready-to-wear clothing of the day by designers from Yves Saint Laurent to Valentino to the ever-present Givenchy. She wore maxi coats belted at the waist, narrow boots, capes, bell-bottom pants, and a head scarf in place of a hat. To make clear her new preference for made-in-Italy fashion, she often appeared dressed by Valentino, in clothes with a typical 1970s flavor: the ruffles, pleats, and silk flowers of hippie couture that made Italian style famous worldwide.

In Rome, Audrey appeared on public occasions, but she could also be glimpsed during moments of her family-focused life: catching a film in the evening, or attending a birthday party or a friend's wedding. To a certain degree her wardrobe reflected her fondness for collecting accessories, including small pieces like scarves and sandals to wear at the beach with her ever-present oversize dark glasses, or the handcrafted items she picked up on her trips around the world. The gamine Audrey had matured into a woman who still turned heads and who experienced both her fame and her private life with a look of delight and surprise in her eyes, as though all of life were a mystery yet to be discovered.

This is the Audrey whom her sons remember most fondly, the Audrey whose image infuses family albums with a sense of glamour that is more domestic than Hollywood. Whenever the paparazzi approached, ready to steal a moment from her private life, she always smiled with a mixture of resignation and pleasure; after thirty years in the spotlight, she understood that the press would never leave her alone. The Romans repaid her kindness and poise with the supreme compliment: they considered her one of their own.

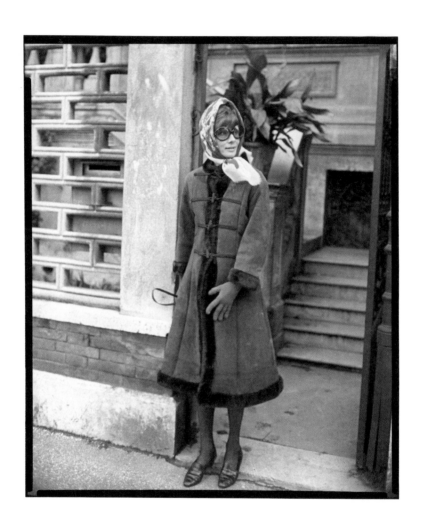

1970. Audrey captured by paparazzi on the doorstep of her husband Andrea Dotti's office, on Via Crescenzio.

SCARF

The concept of elegance extends from head to toe. In Audrey's case, "feeling right" began with a scarf. For both contractual obligations (film studios wanted stars to avoid damaging their hair through overexposure to the sun) and privacy reasons, Audrey rarely went out bareheaded. Her personal wardrobe included as many scarves as the ballet flats for which she was so famous, from a souvenir from India to a classic silk Hermès, and included a range of patterns and fabrics. She was such an avid collector that acquiring scarves could be considered one of her very few vices.

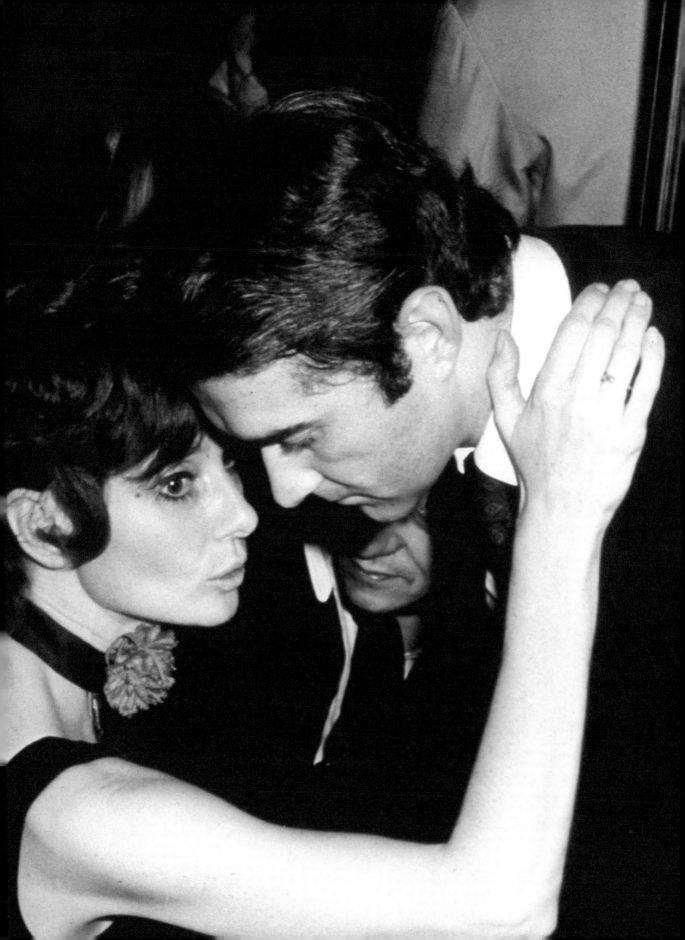

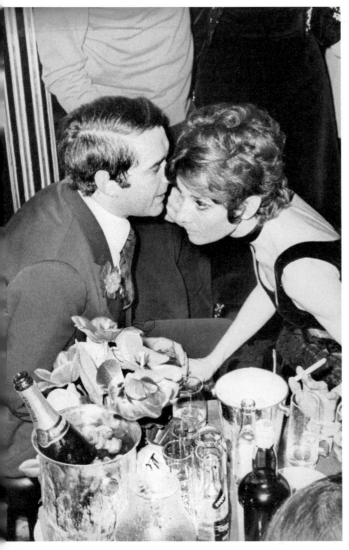
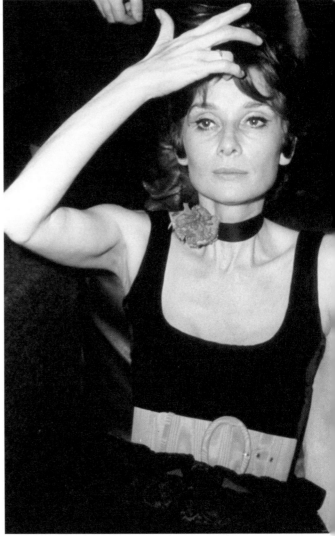

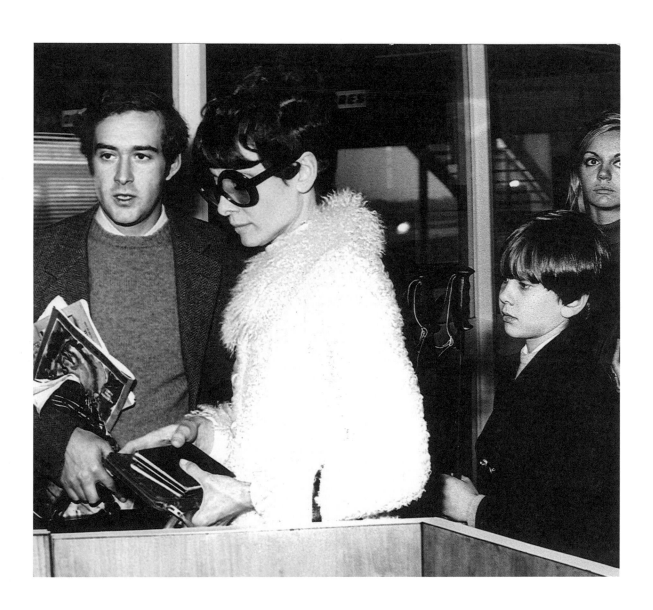

1970. Audrey with her husband Andrea Dotti and son Sean.

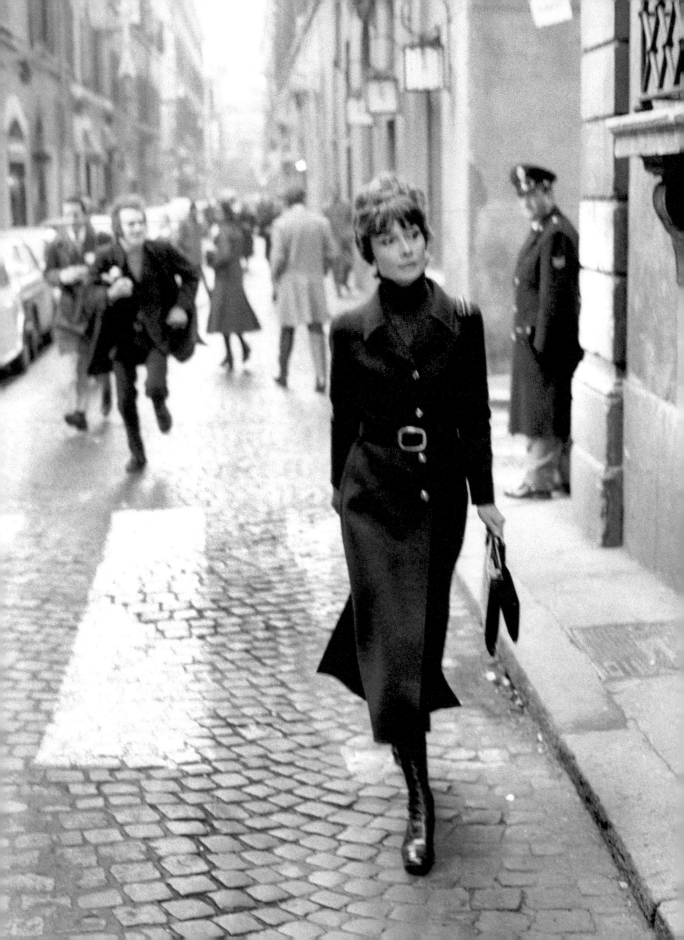

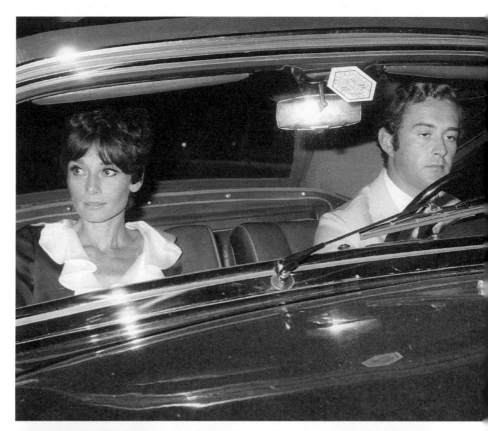

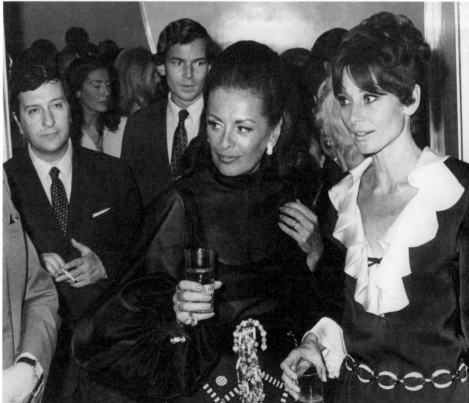

Opposite:
1970. Audrey on a stroll through Rome—literally chased down the street by paparazzi.

1971. Audrey with Andrea Dotti (*top*) and with Irene Galitzine (*bottom*) at the opening of Galitzine's atelier on Via Veneto.

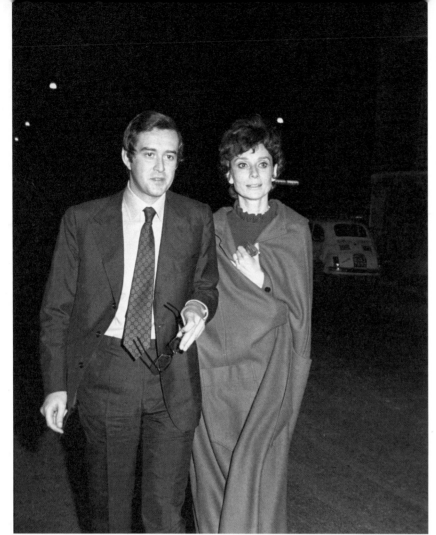

The cape, sophisticated and so of its time in the 1970s, was a basic element in the collections of many designers, from Yves Saint Laurent to Valentino. The cape recalls a certain Roman stoicism and evokes a mysterious and slightly dramatic look that Audrey interpreted in her own way, making it appear at once sporty and regal.

1972. Audrey with Andrea Dotti outside a Roman nightspot.

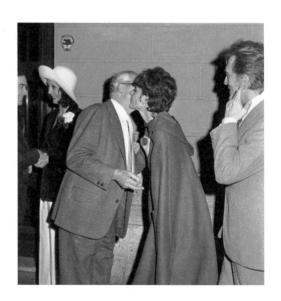

1972. Visible at far right in this shot of Audrey is Kirk Douglas.

Opposite:
1972. Audrey at a party with Alberto Sordi.

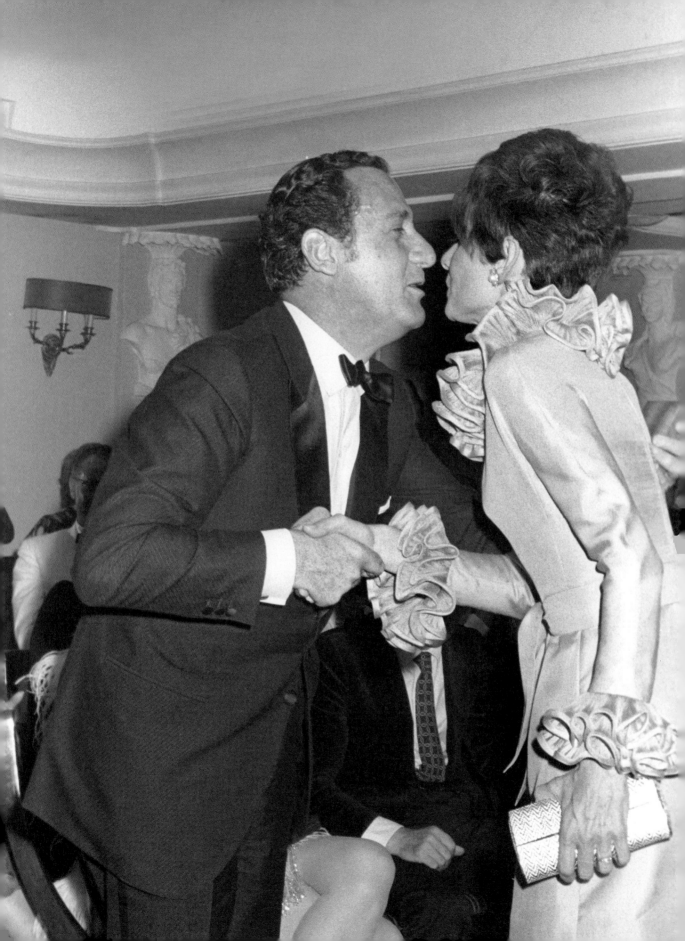

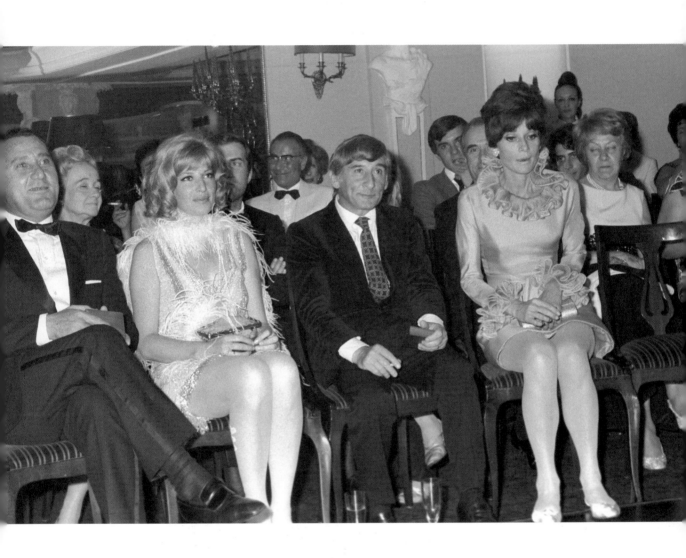

1972. *Left to right*, Alberto Sordi, Monica Vitti, Renato Rascel, and Audrey.

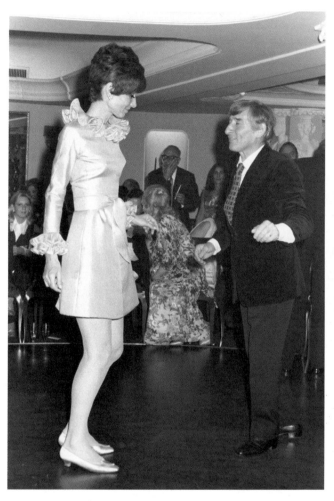

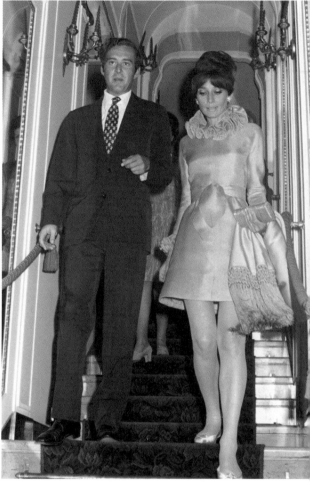

1972. Audrey dancing with Renato Rascel (*left*). Audrey with Andrea Dotti (*right*).

On the beach with Audrey: bikini, windbreaker, and the inevitable scarf with oversize sunglasses. The 1970s was the age of Emilio Pucci, with his vibrant, colorful prints. Audrey on the beach in Rome recalls Jackie O. in Capri, Brigitte Bardot in Saint-Tropez, and Elizabeth Taylor in Acapulco. The beach style of these stars expressed the sensibility of a generation of women who openly sought a more feminine look.

1972. Audrey and Andrea Dotti at the beach.

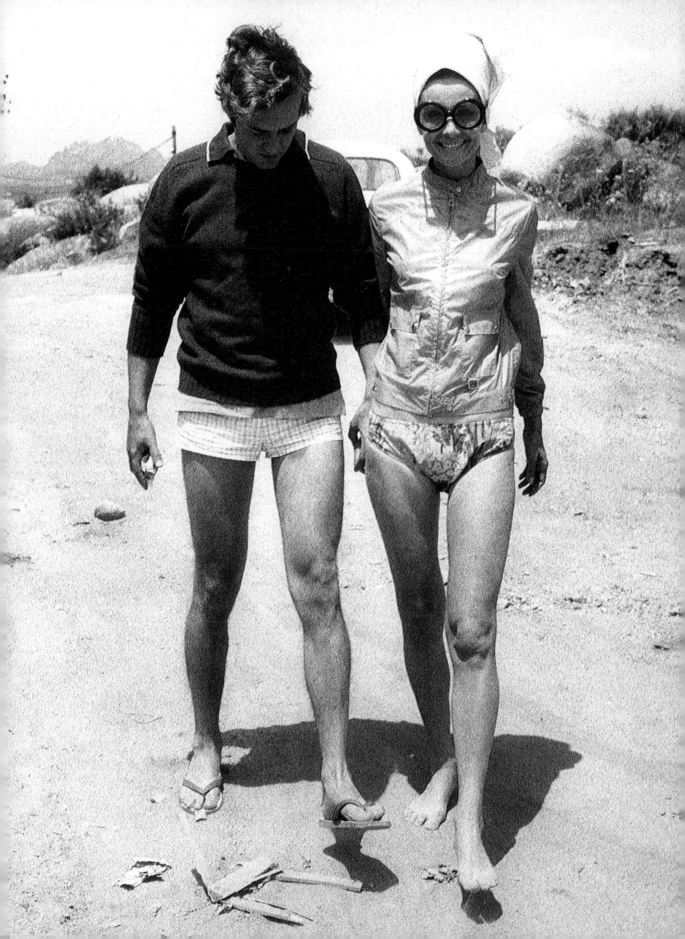

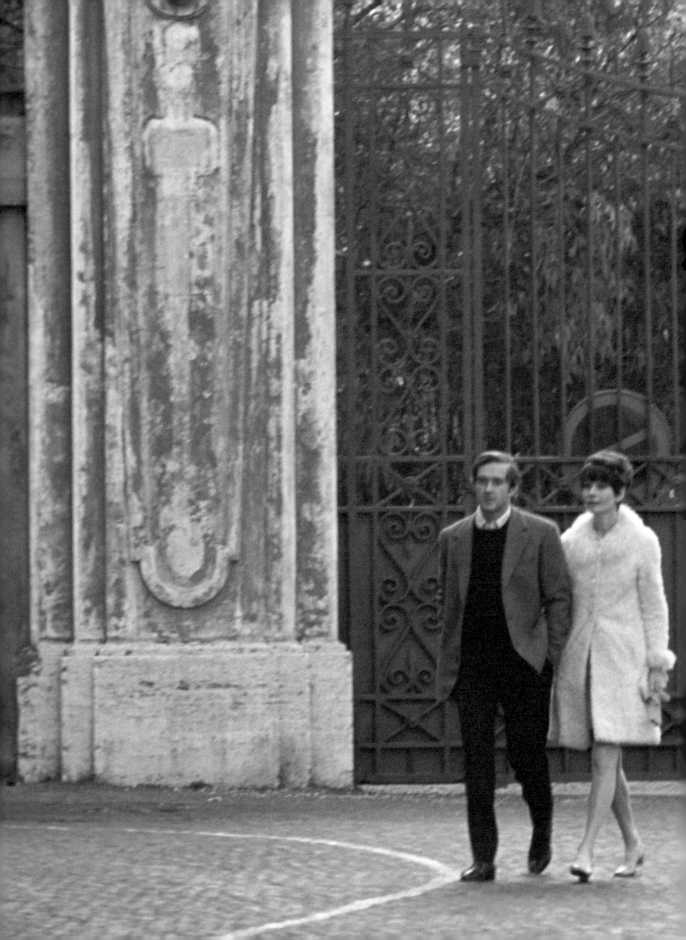

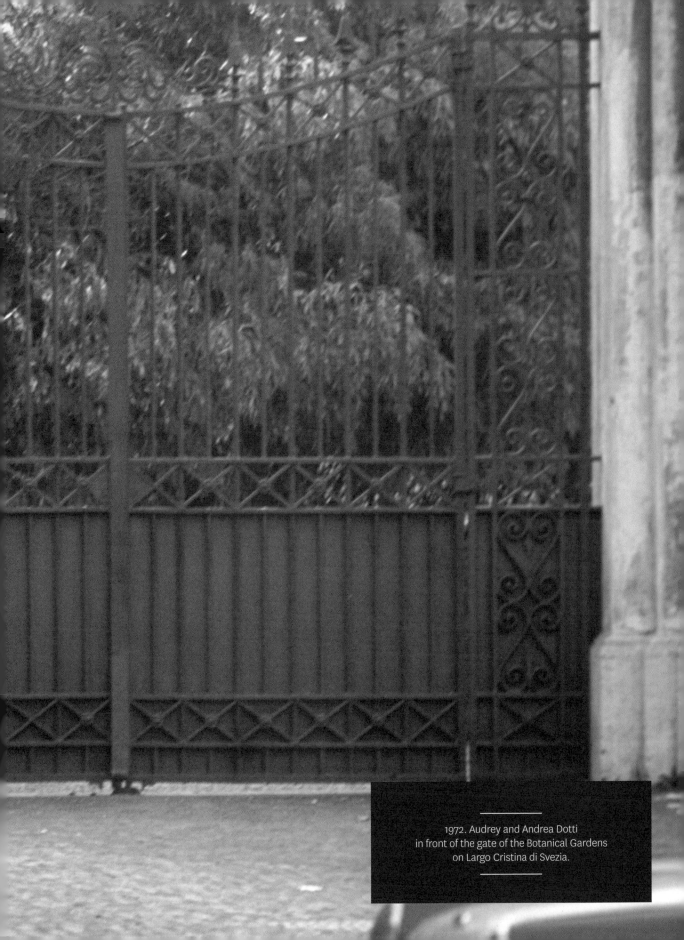

1972. Audrey and Andrea Dotti
in front of the gate of the Botanical Gardens
on Largo Cristina di Svezia.

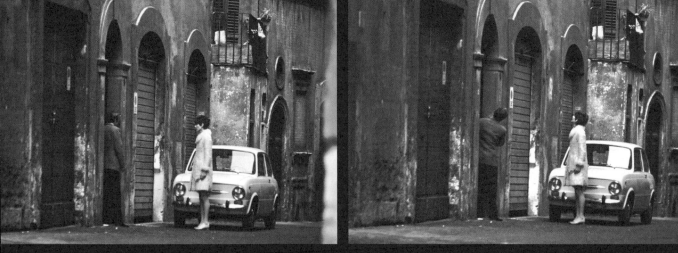

1972. Audrey with Andrea Dotti outside his mother's house in Via della Barchetta.

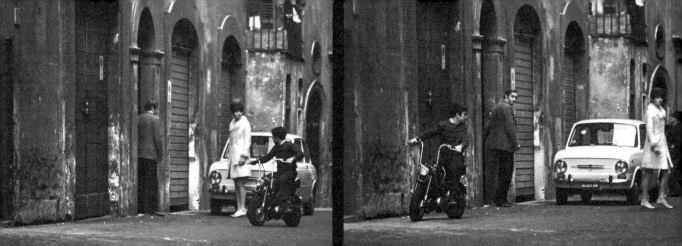

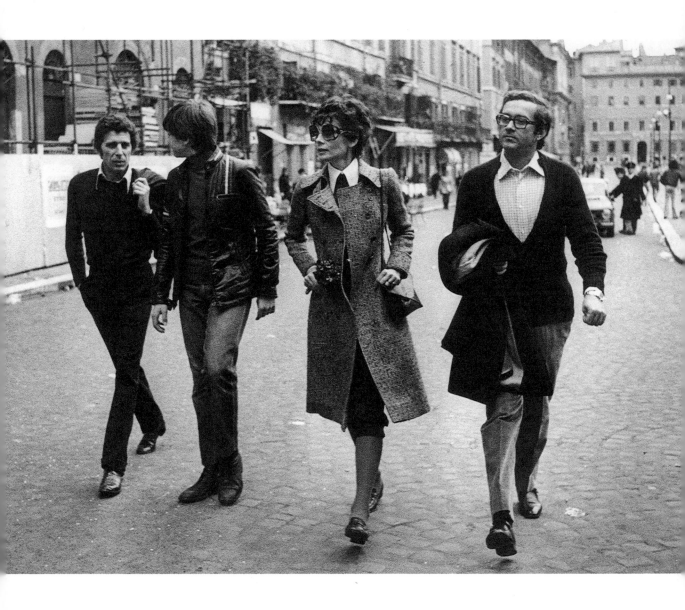

1972. Audrey between Andrea Dotti and her son Sean with Marino Torlonia in Piazza Navona.

Audrey, like a true Roman woman, wore Valentino on important evenings out. At the time, Rome symbolized the jet set and its social life, and Valentino epitomized the international made-in-Italy style. Here, Audrey wears a pale pink dress with ruffled flounces; the look is a bit hippie and a bit boudoir, yet Audrey's boyish haircut brings a chic edge to the frivolity.

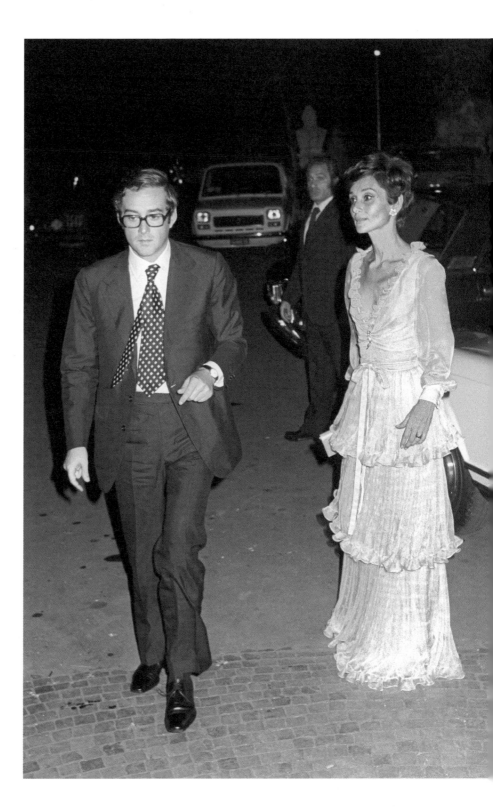

1973. Audrey and Andrea Dotti at the wedding reception of Pilar Crespi at Casina Valadier, Rome.

1973. Audrey with Andrea Dotti
at the Stadio dei Marmi.

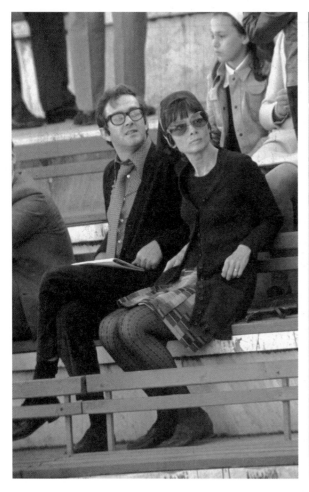
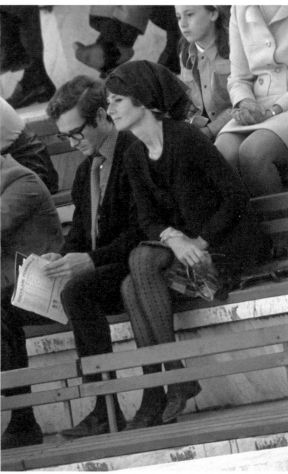

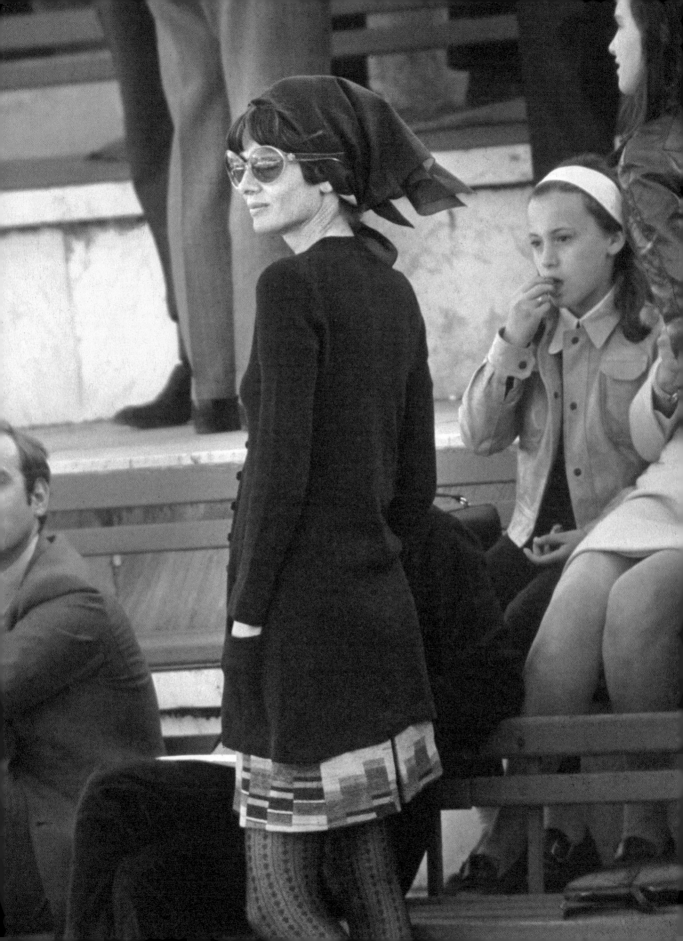

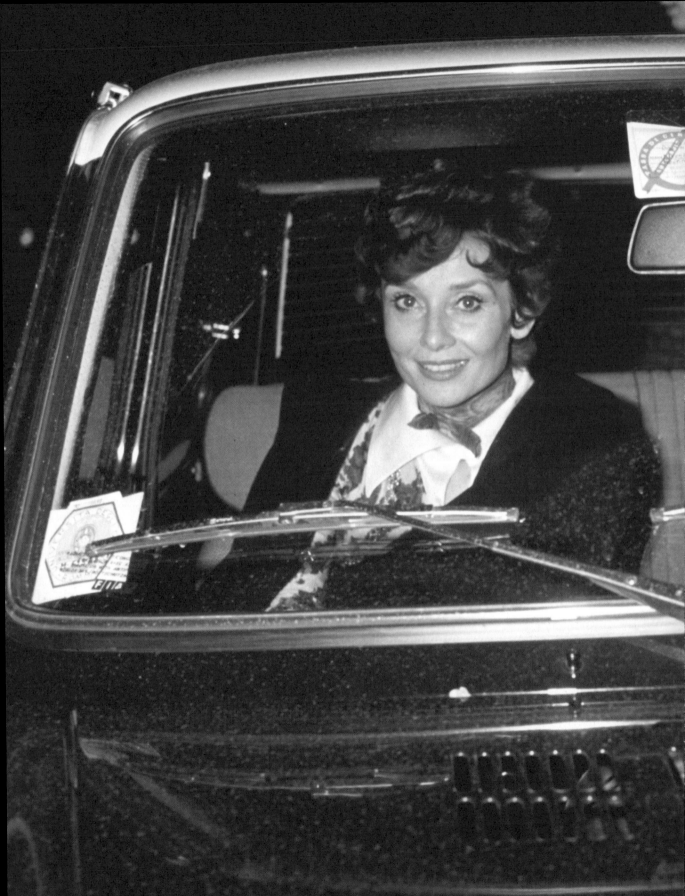

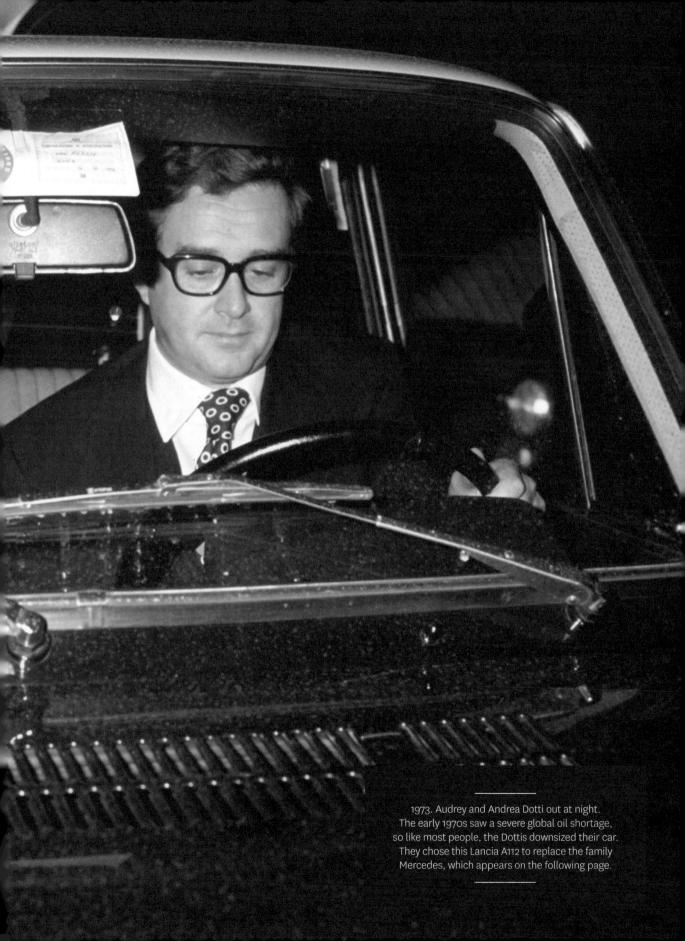

1973. Audrey and Andrea Dotti out at night.
The early 1970s saw a severe global oil shortage,
so like most people, the Dottis downsized their car.
They chose this Lancia A112 to replace the family
Mercedes, which appears on the following page.

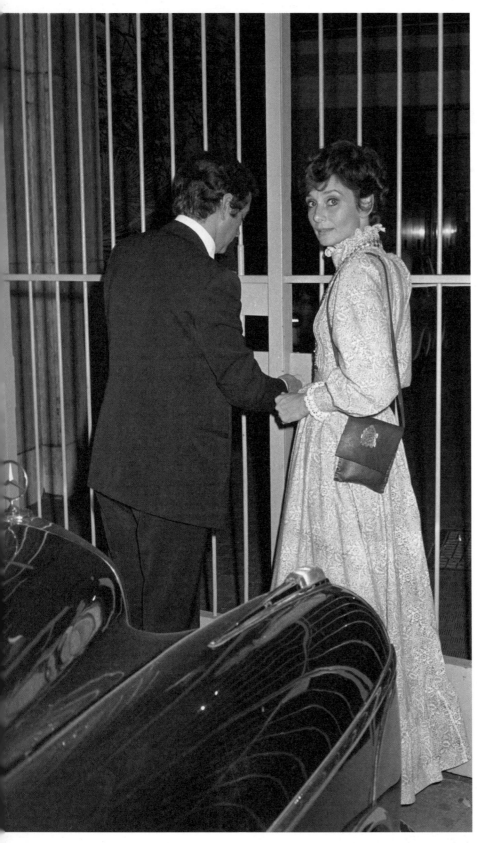

The high collar, puffy sleeves, and flouncy skirt were all components of the hippie style, including its couture version, which was the chic uniform of the 1970s. Audrey loved to complete her look with handcrafted accessories, some of which she collected during her many trips. She never wore showy jewelry.

1974. Audrey and Andrea Dotti at the gate of their house on Via di San Valentino in Parioli.

1974. Audrey and Andrea Dotti
stroll the streets of Rome.

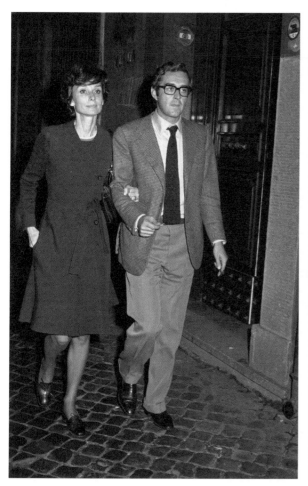

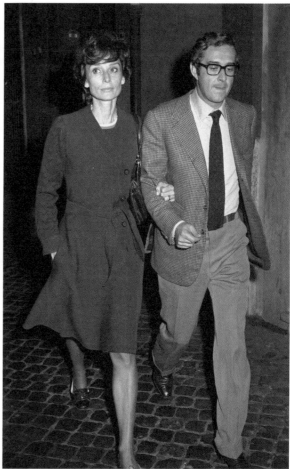

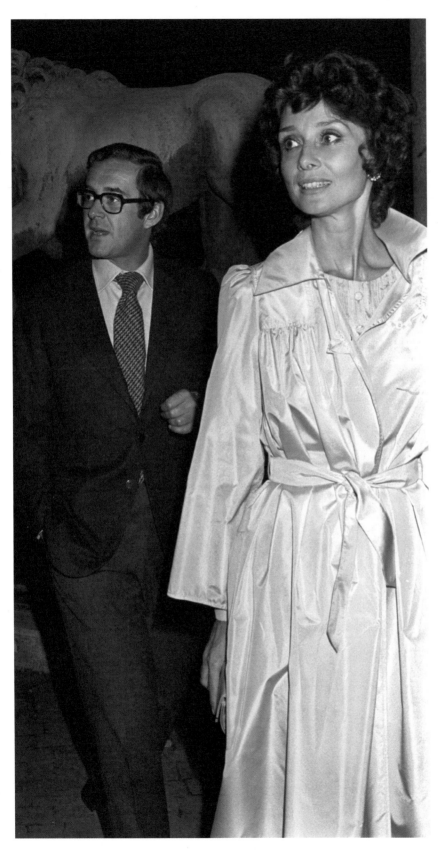

1975. Audrey and Andrea Dotti at the Villa Medici.

Opposite:
Audrey with costumier Umberto Tirelli (*left*) and actor Romolo Valli.

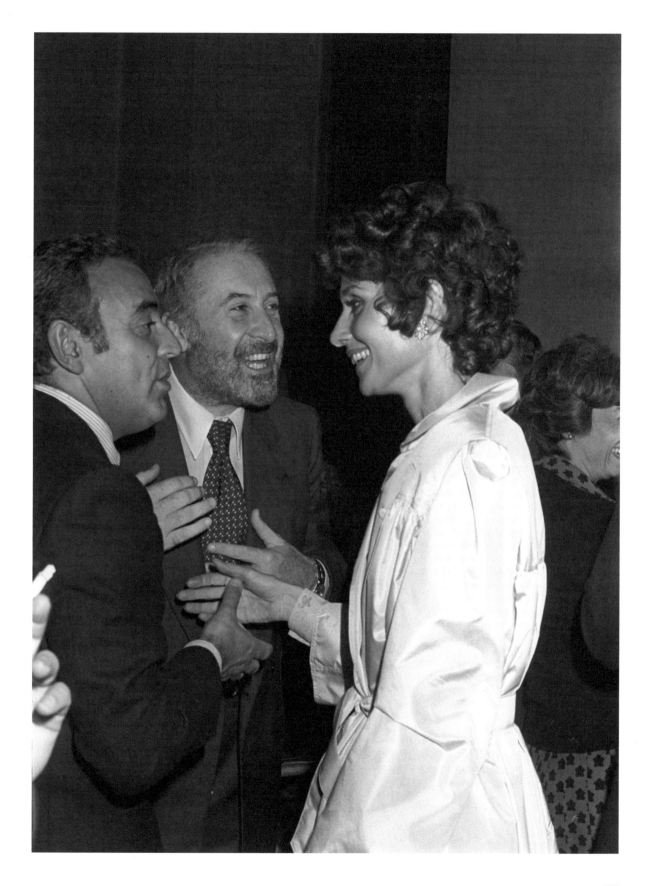

1975. Audrey en route to
her home from a gala evening.

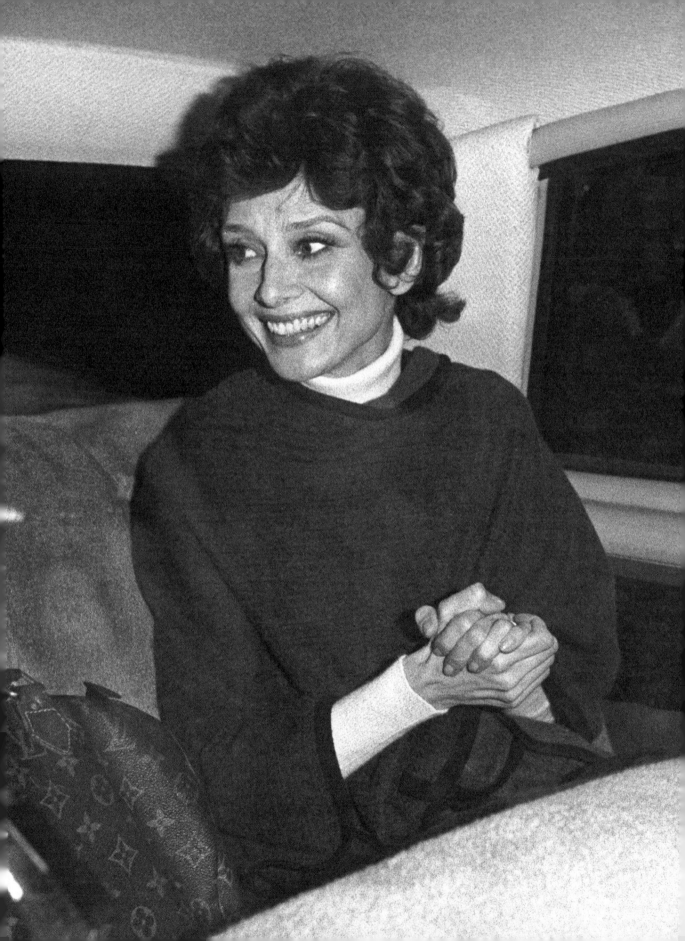

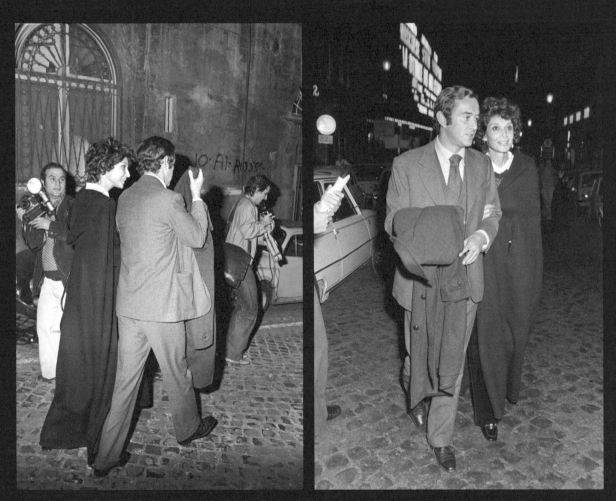

1975. *Above and opposite*, Audrey with Andrea Dotti at the Teatro Sistina.

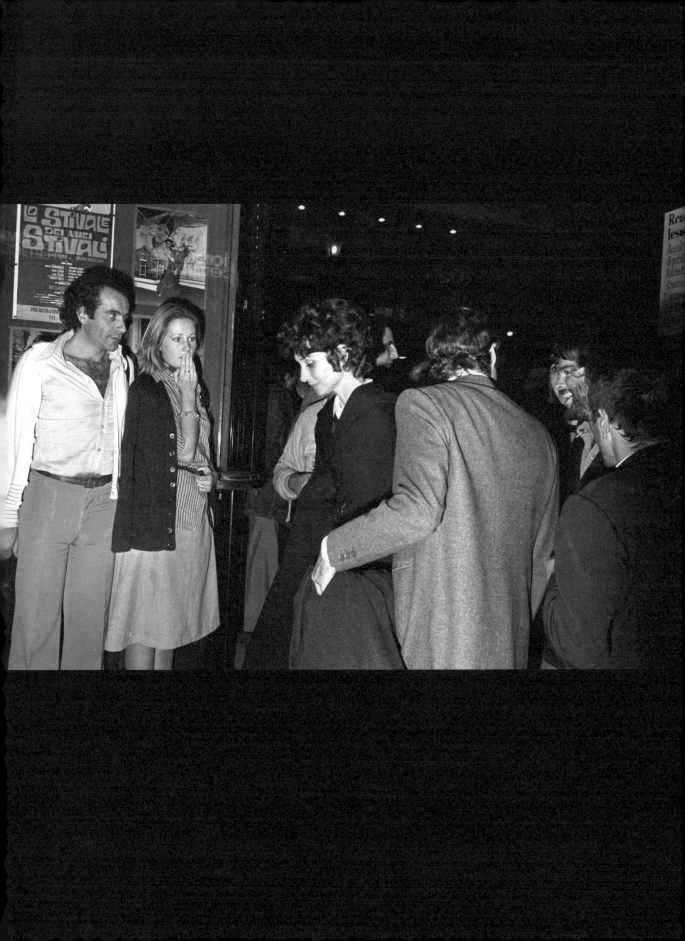

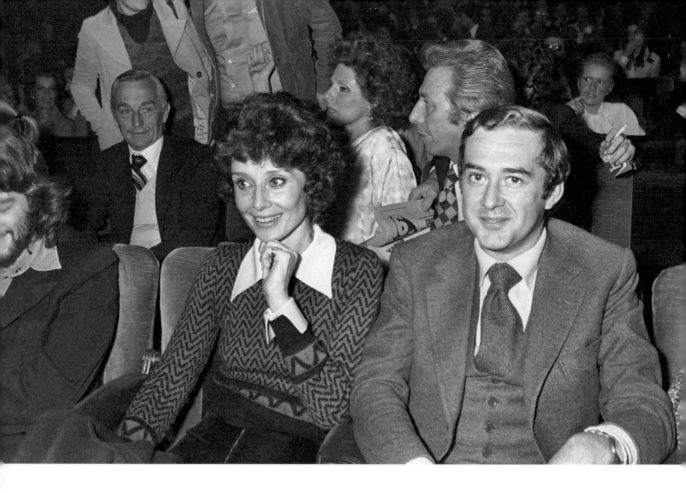

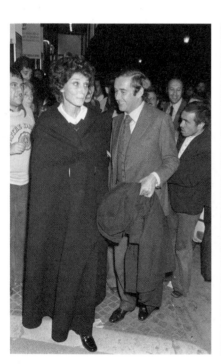

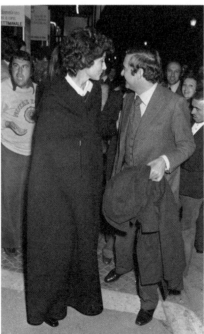

1975. *Above*: Audrey and Andrea Dotti at the Teatro Sistina. Directly behind Audrey is singer Ornella Vanoni.

Left: Audrey and Dotti leaving the show; visible to the left behind Audrey is Italian comedian Jimmy il Fenomeno.

Opposite: 1976. Audrey and Andrea Dotti at an exhibit of the sculptor Mario Ceroli at La Tartaruga, the historical art gallery of Plinio De Martiis on Via Sistina.

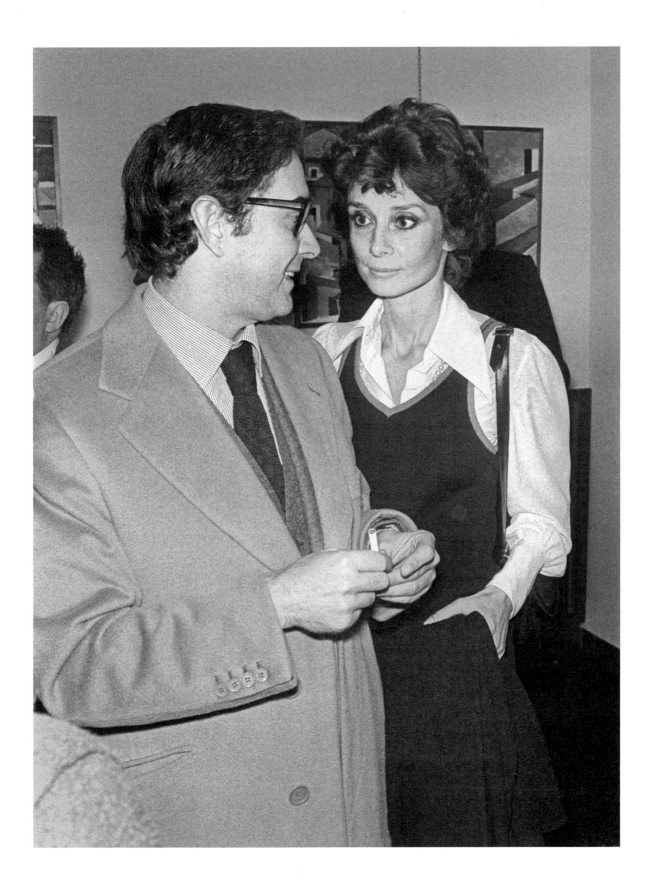

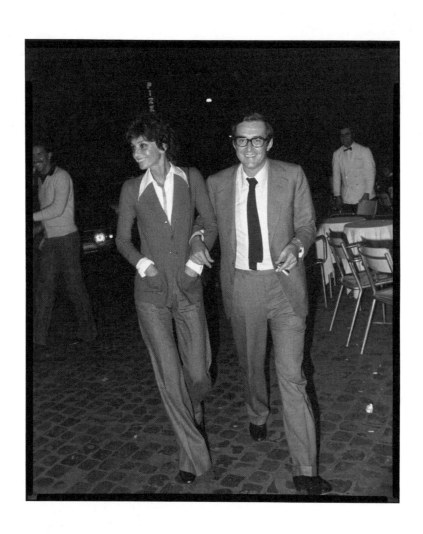

1976. Audrey and Andrea Dotti in the streets of Rome.

CASUAL LOOK

When Audrey became a full-time wife and mother, her style remained as elegant as ever. It became less reflective of the screen roles for which she was famous, of course, and her wardrobe choices became more about practicality and ease. She often enhanced her look with handcrafted or exotic details and accessories. She also liked a tailored look with a masculine influence, as shown here. The oversized cardigan, flannel pants, and silk blouse are timeless classics: simple, confident, and subdued, yet feminine all the same.

Far from the Stage

Though she had almost entirely abandoned her film career, Audrey's magnetism remained strong. Her inner star glowed when she strolled the streets, walked her dogs, shopped for groceries, participated in the Roman tradition of buying pastries on Sunday, and held her son's or husband's arm. She was by all means a Roman, living her life close to her dearest friends.

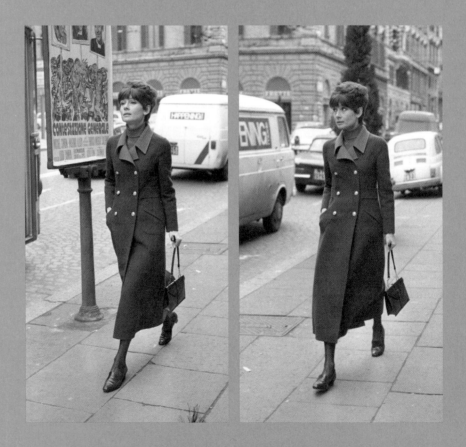

1970. Audrey on Corso Vittorio Emanuele II.

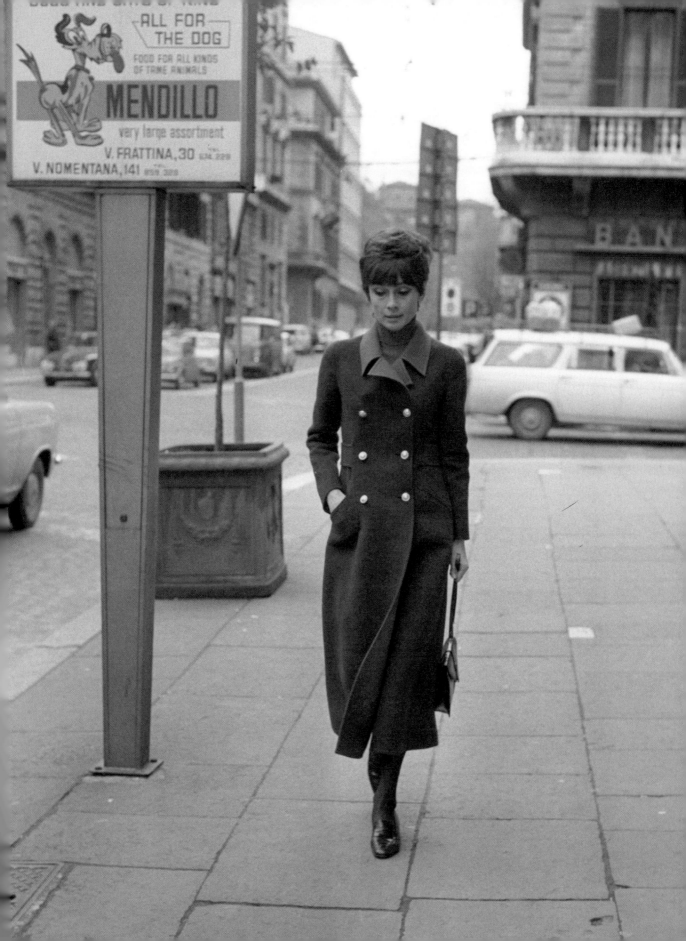

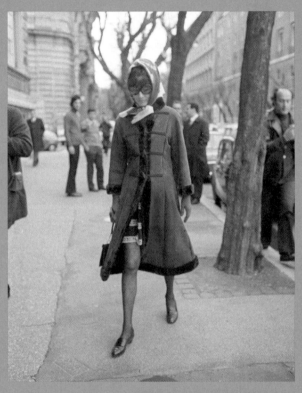 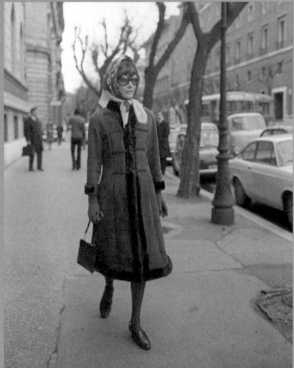

1970. Audrey during an autumn stroll on Via Crescenzio.

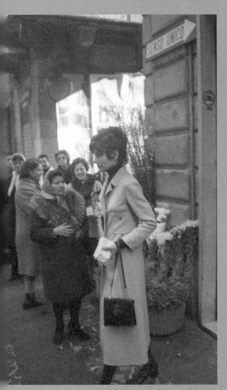
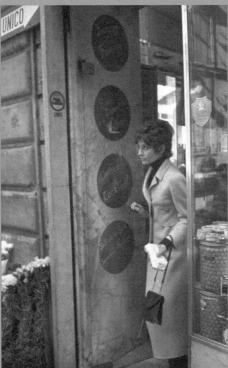
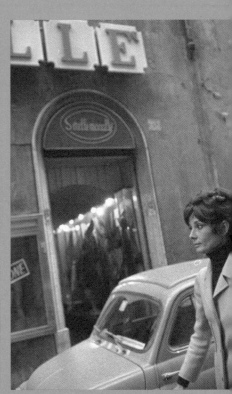

1971. Shopping on Via Belsiana.

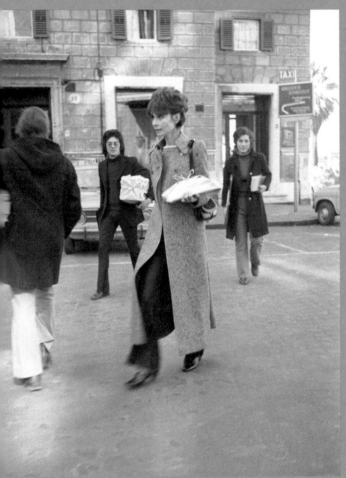
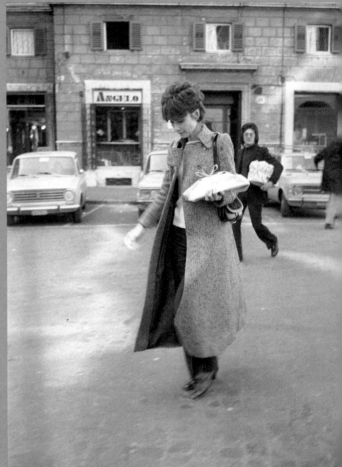

1972. Audrey with a tray of pastries. She is accompanied by her ever-faithful family driver, Franco.

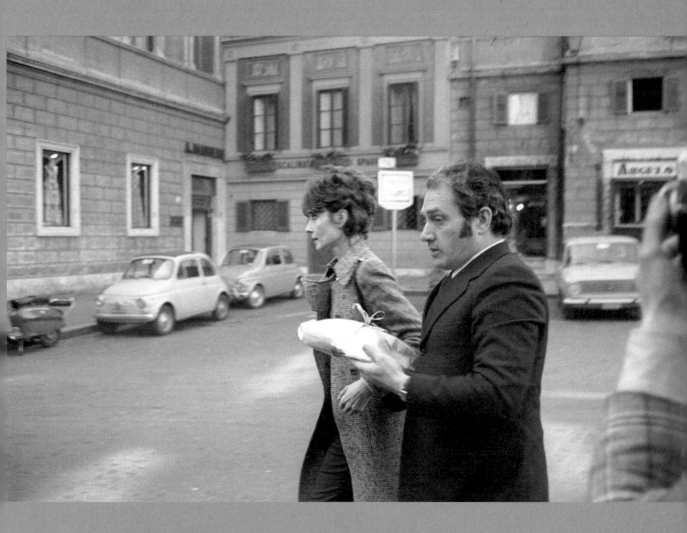

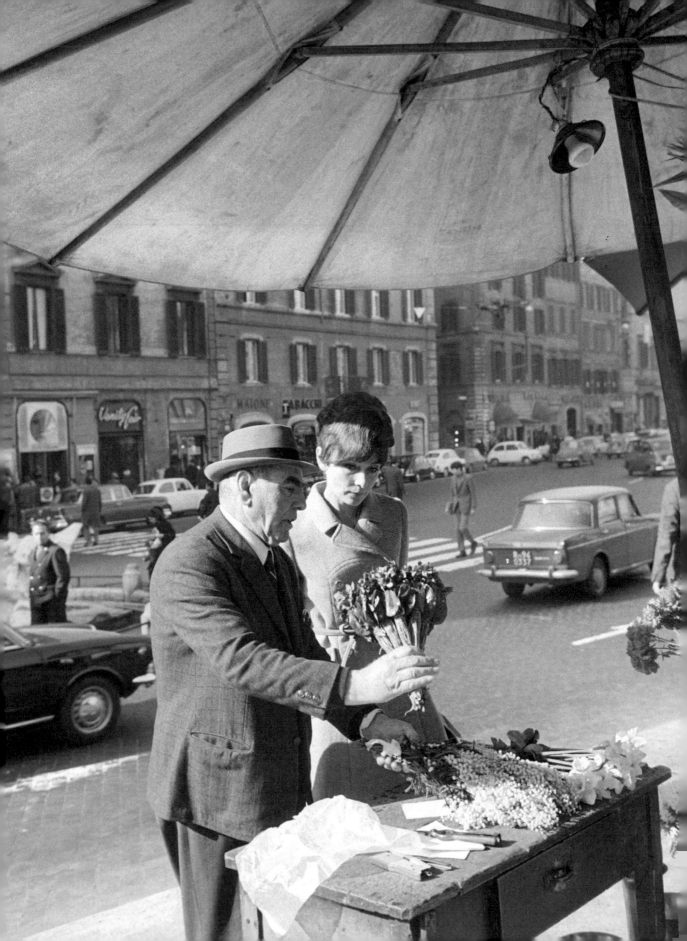

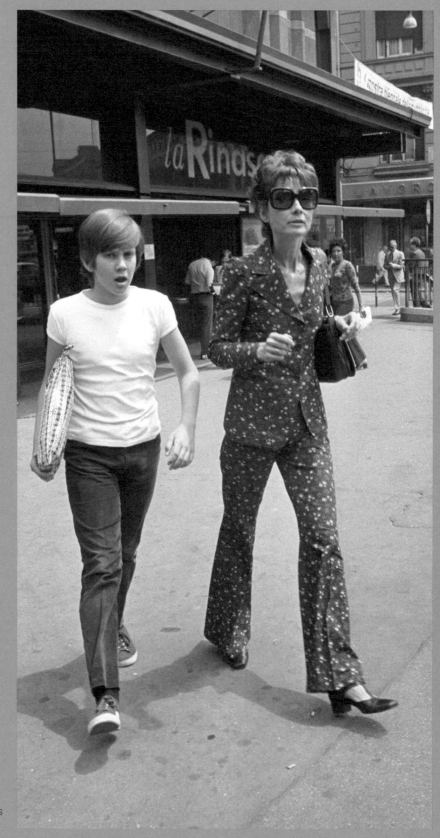

Opposite:
1973. Audrey at the florist in Piazza di Spagna.

1972. Audrey with her son Sean in front of the Rinascente, the famous department store in Piazza Fiume.

183

APPENDICES

BIOGRAPHICAL NOTES

This biography refers solely to Audrey's years in Rome, the subject of this book. For her complete biography, see her official website: www.audreyhepburn.com.

1952

Filming begins on *Roman Holiday*, Audrey's first major film. Twenty-four years old, she is engaged to Lord James Hanson; the Fontana sisters make her wedding gown. The couple soon breaks up, and the gown is given to a young Italian girl.

1954

Audrey is awarded an Academy Award for best actress for her performance in *Roman Holiday*. During a dinner in London celebrating the opening of the film, her friend Gregory Peck introduces her to Mel Ferrer. The couple marries in Switzerland in September that same year. Also in 1954, *Sabrina*, directed by Billy Wilder and costarring Humphrey Bogart and William Holden, is released.

1955

Audrey's performance in *Sabrina* wins her a BAFTA award for best actress. Many of the outfits Audrey wears on the set are designed by Hubert de Givenchy, a collaboration that laid the groundwork for a friendship that lasted the rest of her life.

1956

War and Peace, directed by King Vidor and filmed almost entirely on the sets of Cinecittà, is released. Audrey is again in Rome, along with her husband Mel Ferrer, Henry Fonda, and Vittorio Gassman.

1957

A year of romantic comedies. In *Funny Face*, Audrey "learns" to dance following the lead of the master Fred Astaire, and in *Love in the Afternoon* she falls into the arms of playboy Gary Cooper.

1958

"Rome, by all means, Rome!" as in the famous line from *Roman Holiday*: Audrey is again at Cinecittà, this time to film *The Nun's Story*, directed by Fred Zinnemann. The film takes her to Africa for the first time, the continent where Audrey will later return as a goodwill ambassador for UNICEF.

1959

In *Green Mansions*, directed by Mel Ferrer, Audrey performs with Anthony Perkins. She and Mel announce they are expecting their first child. Sean is born in July of the following year.

1960

In *The Unforgiven*, a Western directed by John Huston, Audrey stars opposite Burt Lancaster. On set in 1959, a near-fatal riding accident forces her into a long convalescence. Sean is three months old when Audrey begins studying the character of Holly Golightly for *Breakfast at Tiffany's*.

1961

Audrey stars in *Breakfast at Tiffany's*, directed by Blake Edwards. Truman Capote, author of the novel, hoped for Marilyn Monroe to play Holly Golightly and considers Hepburn a poor choice. Audrey has trouble identifying with the overly free-and-easy Holly. The film and its theme song, "Moon River," by Henry Mancini, find their place in cinematic history, along with the little black dress designed by Givenchy.

1962

In *The Children's Hour*, Audrey acts with Shirley MacLaine for the first time. The story depicts a lesbian scandal; perhaps because of bigotry, the film does not meet with

great commercial success despite many nominations and awards.

1963

Charade, directed by Stanley Donen, starring Cary Grant and Walter Matthau, brings Audrey back to Paris. At almost the same time, she works on *Paris When It Sizzles* with William Holden, but as a result of numerous problems on the set, the film isn't released until 1964.

1964

Audrey makes *My Fair Lady*, directed by George Cukor, and it is one of her most controversial successes. She initially insisted that the part be given to Julie Andrews, who had given a masterful performance of Eliza Doolittle on Broadway. Also in 1964, thanks to Mel Ferrer and the Red Cross, Audrey locates her father, Joseph Ruston, whom she had not seen for twenty-five years.

1965

Audrey's son Sean is now five and of school age; she wants to devote more time to motherhood and slow down the hectic pace filmmaking forces upon her life. Her home in Switzerland increasingly becomes an oasis of peace from Hollywood.

1966

Once again directed by her friend Wyler and dressed by Givenchy, Audrey acts beside Peter O'Toole in one of her most brilliant comedies, *How to Steal a Million*. The car that Audrey drives through the streets of Paris is a Bianchina Special Cabriolet.

1967

Audrey makes *Two for the Road* and *Wait Until Dark*, directed respectively by Stanley Donen and

Terence Young. This is a difficult year for Audrey, who sees her marriage to Mel Ferrer coming to an end.

1968

After a fifteen-year career with resounding successes, Audrey decides to retire from filmmaking and dedicate herself to Sean and find a little serenity. On a trip to Greece she meets Roman psychiatrist Andrea Dotti through mutual friends and falls in love with him.

1969

On January 18 Audrey and Andrea are married; she wears a very simple pink wool dress designed by Givenchy. Once again, roads lead Audrey back to Rome.

1970

Audrey gives birth to her second son, Luca, and she chooses to play what she calls her "favorite role," that of wife and mother.

In later years Audrey took several minor roles out of friendship with the director or actors. She performed in *Always* (1989), directed by Steven Spielberg, because she so greatly admired the man who had created *E.T.* in 1982.

1988

Audrey is nominated a UNICEF international goodwill ambassador and dedicates herself entirely to her most important and difficult role yet. She visits more than twenty countries and witnesses atrocious injustices and suffering, which she ceaselessly brings to the attention of world leaders. Today, twenty years later, the tragedy that Audrey saw in Somalia in 1992 is being repeated. She herself defined it as hell. That trip was her last.

FILMOGRAPHY

The director of each film is indicated below.
The dates given are the release dates.

Dutch in Seven Lessons
Documentary
Charles Hugenot van der Linden
Holland, 1948

Laughter in Paradise
Mario Zampi
Great Britain, 1951

One Wild Oat
Charles Saunders
Great Britain, 1951

The Lavender Hill Mob
Charles Crichton
Great Britain, 1951

Young Wives' Tale
Henry Cass
Great Britain, 1951

The Secret People
Thorold Dickinson
Great Britain, 1952

Nous Irons à Monte Carlo
(French version of
Monte Carlo Baby)
Jean Boyer
France, 1952

Monte Carlo Baby
Jean Boyer, Lester Fuller
Great Britain, 1953

Roman Holiday
William Wyler
USA/Italy, 1953

Sabrina
Billy Wilder
USA, 1954

War and Peace
King Vidor
Italy/USA, 1956

Funny Face
Stanley Donen
USA, 1957

Love in the Afternoon
Billy Wilder
USA, 1957

Green Mansions
Mel Ferrer
USA, 1959

The Nun's Story
Fred Zinnemann
USA, 1959

The Unforgiven
John Huston
USA, 1960

Breakfast at Tiffany's
Blake Edwards
USA, 1961

The Children's Hour
William Wyler
USA, 1961

Charade
Stanley Donen
USA, 1963

Paris When It Sizzles
Richard Quine
USA, 1964

My Fair Lady
George Cukor
USA, 1964

How to Steal a Million
William Wyler
USA, 1966

Two for the Road
Stanley Donen
Great Britain, 1967

Wait Until Dark
Terence Young
USA, 1967

Robin and Marian
Richard Lester
USA, 1976

Bloodline
Terence Young
USA/Germany, 1979

They All Laughed
Peter Bogdanovich
USA, 1981

Always
Steven Spielberg
USA, 1989

PRINCIPAL THEATRICAL AND TELEVISION WORKS

High Button Shoes
Musical
1948
Archie Thomson

Sauce Tartare
Musical
1949
Produced by Cecil Landeau

Sauce Piquante
Musical
1950
Produced by Cecil Landeau

Gigi
Play
Raymond Roulear
1951

"Rainy Day at Paradise Junction"
Episode in the series
CBS Television Workshop
1952

Ondine
Play
Alfred Lunt
1954

"Mayerling"
Episode in the series
Producers' Showcase; film
Kirk Browning/Anatole Litvak
1957

Love Among Thieves
TV movie
Roger Young
1987

Gardens of the World with Audrey Hepburn
TV miniseries/documentary
Bruce Franchini
1993

AWARDS AND RECOGNITION

"The greatest victory has been to be able to live with myself, to accept my shortcomings . . . I'm a long way from the human being I'd like to be. But I've decided I'm not so bad after all."
—Audrey Hepburn

Following are some of the awards and honors bestowed on Audrey Hepburn by a world that found her far better than "not so bad after all."

Official source:
Audrey Hepburn Children's Fund
www.audreyhepburn.com

1952
Theatre World Award, "Promising Personalities" of the 1951–1952 Theatre Season for *Gigi*, *Theatre World*
Best Debut Performance by an Actress for *Gigi*, The Billboard Annual Donaldson Award for Outstanding Achievement in Theatre

1953
Filmdom's Famous Fives for "Outstanding Screen Performance and Personal Achievement," *The Film Daily*
One of America's Five Most Popular Performances by a Motion Picture Actress for *Roman Holiday*, *Photoplay* magazine
One of America's Five Most Promising Newcomers, *Photoplay* magazine
Blue Ribbon Award for *Roman Holiday*, *Boxoffice* magazine

1954
Best Actress Award (1953) for *Roman Holiday*, New York Film Critics Circle
Filmdom's Famous Fives for "Outstanding Screen Performance and Personal

Achievement," *The Film Daily*
Modern Screen's Top Ten Award, *Modern Screen*
Look Award, Actress of the Year (1953). Presented by *Look* magazine on "Colgate Comedy Hour," NBC-TV
Best Film Actress (1953) for *Roman Holiday*, British Academy of Film and Television Arts
Golden Globe Award: Best Motion Picture Actress (1953) for *Roman Holiday*, Hollywood Foreign Press Association
Academy Award: Best Actress (1953) for *Roman Holiday*, Academy of Motion Picture Arts and Sciences
Tony Award: Best Dramatic Actress for *Ondine*, the American Theatre Wing and the League of American Theatres and Producers

1955
Best Actress Nomination (1954) for *Sabrina*, New York Film Critics Circle
Golden Globe, Henrietta Award: World Film Favorite, Female, Hollywood Foreign Press Association
Most Appreciated Foreign Actress, presented by the Finnish Cinema
Best Film Actress Nomination (1954) for *Sabrina*, British Academy of Film and Television Arts
Academy Award Nomination: Best Actress (1954) for *Sabrina*, Academy of Motion Picture Arts and Sciences

1956
Victoire du Cinéma Français Award (1955)
Modern Screen Award: Best Performance for *War and Peace*

1957
Best Actress Nomination (1956) for *War and Peace*, New York Film Critics Circle
Best Film Actress Nomination (1956) for *War and Peace*, British Academy of Film and Television Arts
Golden Globe Nomination: Best Motion Picture Actress, Drama (1956) for *War and Peace*, Hollywood Foreign Press Association

1958
Golden Globe Nomination: Best Motion Picture Actress, Musical/Comedy (1957) for *Love in the Afternoon*, Hollywood Foreign Press Association
Best Actress Nomination (1957) for *Love in the Afternoon*, New York Film Critics Circle
Golden Laurel Award: First Place, Top Female Comedy Performance for *Love in the Afternoon*
Golden Laurel Award Nomination: Top Female Star

1959
Filmdom's Famous Fives for "Outstanding Screen Performance and Personal Achievement," *The Film Daily*
Street dedication: Audrey Hepburn Laan ("Audrey Hepburn Lane") in Doorn, Netherlands
Zulueta Prize: Best Actress for *The Nun's Story*, San Sebastian International Film Festival
Best Film Actress of 1959, Variety Club of Great Britain

1960
Hollywood Walk of Fame Star, Motion Picture Category, 1650 Vine Street, Hollywood, California
Best Actress Award (1959) for *The Nun's Story*, New York Film

Critics Circle
Adam 'n Eve Award, Motion Picture Costumers
Best Actress Award (1959) for *The Nun's Story*, British Academy of Film and Television Arts
David di Donatello Best Foreign Actress Award for *The Nun's Story*, Accademia del Cinema Italiano
Academy Award Nomination: Best Actress (1959) for *The Nun's Story*, Academy of Motion Picture Arts and Sciences
Golden Globe Nomination: Best Motion Picture Actress, Drama (1959), for *The Nun's Story*, Hollywood Foreign Press Association
Golden Laurel Award: Second Place, Top Female Dramatic Performance for *The Nun's Story*
Golden Laurel Award Nomination: Top Female Star

1961
Cleveland Critics Circle Award: Best Actress, Cleveland Critics
Golden Laurel Award Nomination: Top Female Star
Filmdom's Famous Fives for "Outstanding Screen Performance and Personal Achievement," *The Film Daily*

1962
Golden Globe Nomination: Best Motion Picture Actress, Musical/Comedy (1961) for *Breakfast at Tiffany's*, Hollywood Foreign Press Association
David di Donatello Best Foreign Actress Award for *Breakfast at Tiffany's*, Accademia del Cinema Italiano
Academy Award Nomination: Best Actress (1961) for *Breakfast at Tiffany's*,

Academy of Motion Picture Arts and Sciences
Golden Laurel Award: Third Place, Top Female Comedy Performance for *Breakfast at Tiffany's*
Golden Laurel Award: Third Place, Top Female Star
Golden Laurel Award Nomination: Top Female Dramatic Performance for *The Children's Hour*

1963
Golden Laurel Award Nomination: Top Female Star

1964
Golden Globe Nomination: Best Motion Picture Actress, Musical/Comedy (1963), for *Charade*, Hollywood Foreign Press Association
Victoire du Cinéma Français Award
Golden Laurel Award: Third Place, Top Female Comedy Performance for *Charade*
Golden Laurel Nomination: Top Female Star

1965
Best Actress Award (1964) for *My Fair Lady*, New York Film Critics Circle
Best Film Actress (1963) for *Charade*, British Academy of Film and Television Arts
David di Donatello Best Foreign Actress Award for *My Fair Lady*, Accademia del Cinema Italiano
Golden Globe Nomination: Best Motion Picture Actress, Musical/Comedy (1964), for *My Fair Lady*, Hollywood Foreign Press Association
Golden Laurel Award Nomination: Top Female Star
Golden Laurel Award: Third Place, Female Comedy Performance for *My Fair Lady*

1966
Golden Laurel Award Nomination: Top Female Star
Cleveland Critics Circle Award: Best Actress

1968
Golden Laurel Award Nomination: Top Female Star
Maschera d'Argento Award: Achievement in the Arts
Best Actress Award Nomination (1967) for *Wait Until Dark*, New York Film Critics Circle
Golden Globe Nomination: Best Motion Picture Actress, Drama (1967) for *Wait Until Dark*, Hollywood Foreign Press Association
Golden Globe Nomination: Best Motion Picture Actress, Musical/Comedy, for *Two for the Road*, Hollywood Foreign Press Association
Academy Award Nomination: Best Actress (1967) for *Wait Until Dark*, Academy of Motion Picture Arts and Sciences
Special Tony Award, the American Theatre Wing and the League of American Theatres and Producers
Nastro d'Argento (Silver Ribbon Award), Italian National Syndicate of Film
Golden Laurel Award: Second Place, Top Female Star
Golden Laurel Award: Third Place, Female Dramatic Performance for *Wait Until Dark*
Golden Laurel Award Nomination: Top Female Star

1976
Variety Club of New York, Humanitarian Award for contributions to the world of motion pictures and charitable efforts on behalf of all children of all nations, Variety—The Children's Charity of New York

1987
Commandeur de L'Ordre des Arts et des Lettres for significant contributions to furthering the arts in France and throughout the world. Presented by the French minister of culture and communications

1988
The International Danny Kaye Award for Children. Presented by the U.S. Committee for UNICEF

1989
International Humanitarian Award. Presented for the first time in history by the Institute for Human Understanding
Prix d'Humanité Award

1990
The Key to the City of Chicago
"Audrey Hepburn Tulip." Unveiling presentation at the Huis Doorn, Holland
The Key to the City of Indianapolis
Living Treasure Award, New Zealand
Seventh Annual UNICEF Ball honoring Audrey Hepburn
Cecil B. DeMille Award, Golden Globe Lifetime Achievement, Hollywood Foreign Press Association
One of the "50 Most Beautiful People in the World," *People* magazine
Children's Champion Award, Washington UNICEF Council

1991
"Audrey Hepburn Day" proclamation (February 28), in recognition of her UNICEF work, by the mayor of Fort Worth, Texas
Key to the City of Fort Worth
Certificate of Merit for UNICEF ambassadorship; UNICEF "Acts of Consequence" Tour

Golden Plate Award for artistic
achievement in the arts and
public service, "representing
the many who excel in the
great fields of endeavor,"
The American Academy of
Achievement
Bambi Award, Berlin, Germany
Distinguished International
Lifetime Award: Sigma Theta
Tau International Audrey
Hepburn Award, named after
Audrey, given to individuals
in recognition of their
international work on behalf
of children, Sigma Theta
Tau International Nursing
Association
Gala Tribute Honoree, Film
Society of Lincoln Center
Humanitarian Award, Variety
Clubs International
Sindaci per L'infanzia ("Mayors
for Children") Award, UNICEF
Master Screen Artist, USA Film
Festival
Champion of Children Award for
work on behalf of the world's
children, Children's Institute
International

1992
Lifetime Achievement Award,
British Academy of Film and
Television Arts
Key to the City of San Francisco
Presidential Medal of Freedom
Award for contributions to the
arts and humanitarian work
"Audrey Hepburn Day"
proclamation (April 10),

Providence, Rhode Island
Key to the City of Providence
Alan Shawn Feinstein World
Hunger Awards: Honorary
Chair and Speaker. For the
prevention and reduction of
world hunger, Brown University
Gold Medal Award: Casita Maria
Fiesta, Casita Maria
George Eastman Award for
distinguished contribution to
the art of film, George Eastman
House
Lifetime of Style Award, Council
of Fashion Designers of
America

1993
Lifetime Achievement, Screen
Actors Guild of America
Jean Hersholt Humanitarian
Award (1992), Academy
of Motion Picture Arts and
Sciences
Emmy Award: Outstanding
Individual Achievement
Grammy Award: Best Spoken
Word Album for Children for
*Audrey Hepburn's Enchanted
Tales*, the Recording Academy
The Pearl S. Buck Woman's
Award, The Pearl S. Buck
Foundation

1996
Crystal Award, Women in Film

1998
International Humanitarian
Award: "A Special Woman"

2000
Living Legacy Award, Women's
International Center. For
stunning contributions to
humanity and enduring
legacies given to humankind

2002
The Spirit of Audrey Hepburn.
Unveiling of a bronze sculpture
honoring Audrey Hepburn
entitled *The Spirit of Audrey*,
by sculptor John Kennedy, in
the public plaza at UNICEF
headquarters in New York City

2003
Legends of Hollywood, U.S.
Postage Stamp, U.S. Postal
Service

2004
Most Naturally Beautiful Woman
of All Time. First place in an
Evian-organized poll of an
international panel of experts,
composed of beauty editors,
makeup artists, fashion
editors, modeling agencies,
and fashion photographers

Audrey Hepburn is one of the
ten artists in the world who
have completed the so-called
Grand Slam of Show Business,
winning all four of the American
performing prizes: the Tony,
Emmy, Grammy, and Oscar.

PHOTOGRAPHY CREDITS

Editorial coordination
Virginia Ponciroli

Editing
Rossella Savio

Graphic coordination
Dario Tagliabue

Project design and cover
Anna Piccarreta

Layouts
Sara De Michele

Technical coordination
Rosella Lazzarotto

Quality control
Giancarlo Berti

English-language translation
Jay Hyams

English-language typesetting
William Schultz

About the Authors

Ludovica Damiani works and writes for cinema and theater. From 2003 to 2006 she was the assistant director of the press office at the Venice Film Festival. She is the author of the books *Set in Venice* and *Set in Cortina*, the first two volumes in a series about cities as cinematographic sets. She has written and produced plays as tributes to Luchino Visconti and Federico Fellini that have been performed in theaters in Rome, Milan, Venice, Paris, Moscow, and New York. She is currently the communications and project-development manager for the Rome-based film production company Wildside. She also serves as an editorial consultant for the Audrey Hepburn Children's Fund.

Luca Dotti is the son of Audrey Hepburn and the Italian psychiatrist Dr. Andrea Dotti. Luca is a graphic designer and also works with his brother, Sean Hepburn Ferrer, at the Audrey Hepburn Children's Fund. Founded in 1994 in honor of their mother, the fund helps children in need around the world. Dotti lives in Rome with his wife and three children.

Sciascia Gambaccini is a journalist who has served as a fashion editor at *Harper's Bazaar*, *Vanity Fair*, *Glamour*, *Interview*, and *Marie Claire*. She is currently a fashion director at *A* magazine.